ST KILDA

A JOURNEY TO THE END OF THE WORLD

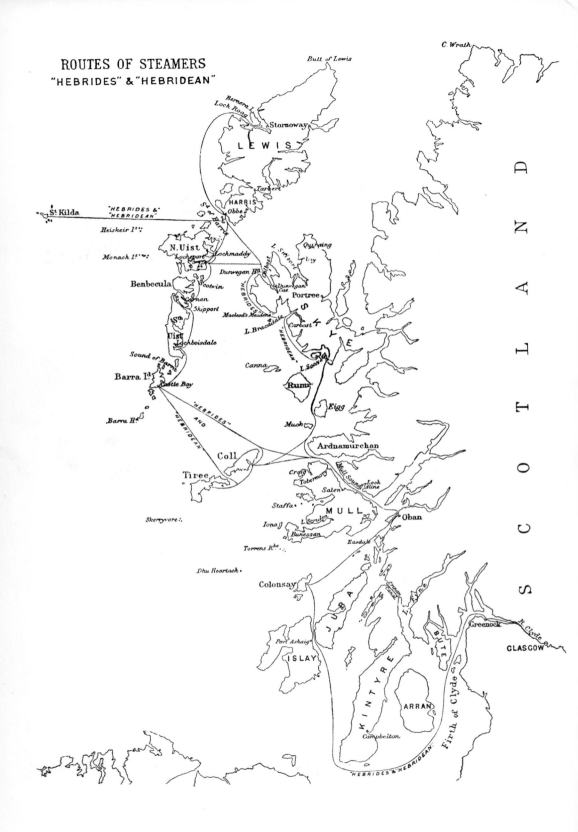

ST KILDA

A JOURNEY TO THE END OF THE WORLD

Campbell McCutcheon

*For my mum and dad,
without whom none of this would have been possible*

AMBERLEY

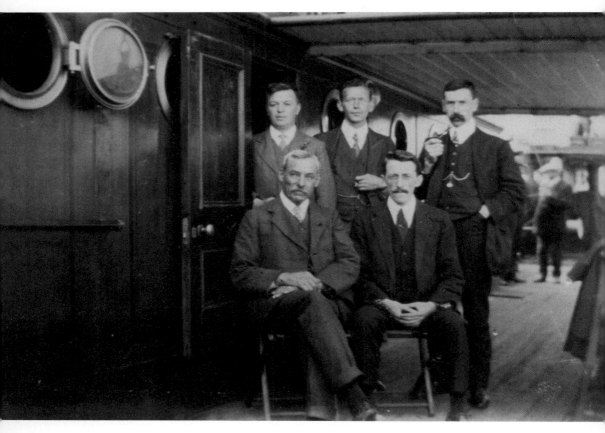

On board the Hebrides.

First published 2002, reprinted 2006. This edition 2008

Amberley Publishing Plc
Cirencester Road, Chalford,
Stroud, Gloucestershire, GL6 8PE

www.amberley-books.com

British Library Cataloguing in Publication Data.
A catalogue record for this book is available from the British Library.

isbn 978 1 84868 057 9

Typesetting and Origination by Diagraf (www.diagraf.net)
Printed in Great Britain

Contents

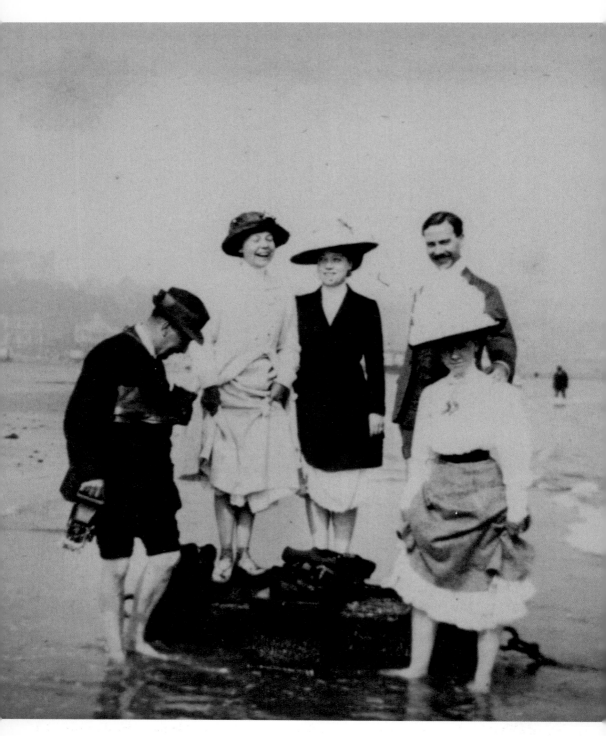

This photograph was taken at Scarborough, the man on the left is one of the photographers of many of the views of St Kilda and the other Hebridean islands shown on these pages.

Introduction

St Kilda, that enigmatic group of islands just fifty miles from the west coast of Harris, has held the imagination of thousands ever since Martin Martin first visited these lonely islands in 1697. Perhaps the most written about of all the Scottish islands, St Kilda has been uninhabited since 1930, when the last few islanders asked the Government to remove them from the island and resettle them on the Scottish mainland. The only human presence now is a rather small army base and the National Trust for Scotland working parties who come during the summer to restore the now-empty cottages of St Kilda's street.

My interest in St Kilda stems from childhood and many happy holidays spent with my parents or my uncle camping in the West Highlands and the Hebrides. My passion for St Kilda was brought to life in 1989 when I was still at university and working part time in a publisher's in Glasgow. One of the first books I worked on was Bob Charnley's *Last Greetings from St Kilda* and the island has held my interest ever since. Although I have never been there, I have been fortunate to acquire some old books on the island and some images of the island from antique postcards. In 2001 I was at a postcard fair in Bristol looking for photographs and postcards of ocean liners for my wife. Amongst the piles of books and old postcards on one stall there was an album of photos. On it was the label 'photos of Lochboisdale, £50'. I picked up the album and turned the first few pages. I recognised the first image as one of Scarinish, on Tiree, then some of Carbost and Dunvegan on Skye. The next page held four photos. The first was of the Pier, St Kilda; second was of the manse being used as a Post Office. There were two other images of the Main Street and I knew then I was going to buy the album. I looked no further through the pictures and asked the dealer if he would pop the album aside and I would collect it later. Looking around the rest of the fair, I managed to find three turn of the twentieth century brochures for tours by the two ships that made regular calls to St Kilda, the *Hebrides* and the *Dunara Castle*.

Later, after lunch, I paid for the album and took it away. It was only then that I looked at the other pages. Quickly I turned to the page with the images of St Kilda and started from there. I turned page after page to see unique image after unique image of St Kilda. It was obvious from looking at the album that it showed a large part of a tour on the SS *Hebrides*, one of the two ships that made regular summer calls to St Kilda from around 1900 until 1930, when the island was evacuated. In the album were some views of Scarborough, York and France, including two of a four funneled ocean liner that I recognised as the SS *France*, which left on her maiden voyage on 20 April 1912, just five days after the ill-fated *Titanic* was sunk. It was the first clue as to the date of

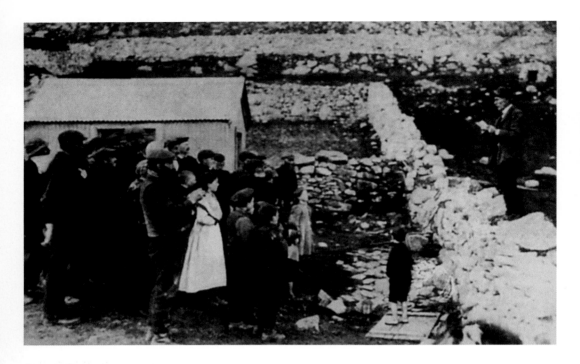

There had been a famine on St Kilda in the winter of 1911 and one of the first ships to call in 1912 brought a supply of food from Sir Thomas Lipton, owner of Lipton's Stores and Tearooms and famous Americas Cup yachtsman, owning the Shamrock series of yachts. This view taken in June 1912 clearly shows the tin shack Post Office, which is not visible in the views in the album.

the album. I knew it could be no earlier than 1911 or 1912. Looking at views of the Main Street of St Kilda, I noticed that the tin shed Post Office wasn't there. In fact, photo two of St Kilda was of the Manse with a huge crowd outside and postcards in the window. This was the island's first Post Office and, so the album could not date from after June 1912 when the new Post Office opened between houses No.5 and 6. The photographs then must have come from a period of hardship on St Kilda when famine was a regular occurrence and only the visits of fishing boats from Aberdeen and Fleetwood, in Lancashire, broke the isolation during the autumn to spring period when it was unsafe to call at the islands because of poor weather.

This album, dating from either 1911 or 1912 was a mystery. Who were the well-travelled tourists? Why did the album start in Scarinish and finish in France? Who had taken the photographs and how had they managed to turn up in a postcard fair in Bristol? The album gave little hint as to its owners. There were no captions either. The dealer I had purchased the album from knew that it was Scottish; after all one of the photos showed a store in Lochboisdale, South Uist. My good fortune was to be able to recognise most of the other places that had been photographed. The dealer had told me that he had bought the album in a North Devon auction for a few pounds, so no clues there. When I started to look closely at the photographs I took a few out of the album. The ones of Dunvegan Castle gave the clue as to the photographer. Three were captioned on the reverse 'photo by Louis Barbé & Wilton Hansions'. The name 'Barbé' was the clue as to why there were pages of French images. *He* was obviously the French connection. How the album appeared in the South West of England and the identity of the other people in

the photos may never be known. All I have been able to ascertain is the approximate date and the names of two of the happy tourists shown on some of the pictures. I'm sure that the islanders themselves are recognisable and that some readers will be able to identify them. I'd love to know and all correspondence can be forwarded via the publishers.

Having little idea of the history of the album I became fascinated with the images. Every time I looked at the ones of St Kilda, I noticed some little detail in the background. They weren't the normal sanitised postcard views that one saw. They were of a candid nature, probably snapped by an inquisitive tourist not used to seeing such hardship and the primitive way of life of the islanders. None had been posed and they showed life on the island as it really was at the time.

A series of images showed a gramophone, and in one of a cow being milked by one of the island women, three young island boys could be seen in the background inspecting the gramophone, which had obviously been brought from on board the *Hebrides*. Was this the first time these young St Kildans had seen or heard a record? In another lollipops were being handed out. From reading various books on St Kilda I knew that the islanders had a penchant for sweets but had never seen a photograph of island children tucking in to what must have been a normal everyday occurrence for mainland children but a rare treat for inhabitants of this remote isle. The images were a unique record, not only of the St Kildan way of life, but also of the cruises that changed the islanders' perception of the outside world and which ultimately led to the terminal decline of the St Kildan community and the evacuation that was to take place some eighteen years after these photographs were taken.

The SS France *sailed on her maiden voyage on 20 April 1912, only five days after* Titanic *sank. This is one of the last photographs in the album. It and that of the Post Office, opposite, probably date the tour to 1911 rather than 1912.*

On board the boat deck of the
SS Hebrides *on the tour to*
St Kilda and the
Western Isles.

Much has been written over the years about St Kilda itself and of the island way of life, but little has been written about the ships that served not just St Kilda but many other remote islands and communities from Islay to the Outer Hebrides. The two ships that called regularly at St Kilda in the twentieth century were both survivors from the nineteenth century, having been built specifically for trade to and from the islands of western Scotland. Week in and week out they called at a variety of piers and harbours on a circuit of the Hebrides that varied little, carrying passengers, freight and livestock to and from a long list of ports that had no other reliable, let alone regular, form of communication with the outside world. It was not only St Kilda that was remote, many of the other islands and communities visited were far from civilisation too, but what made St Kilda different was that the island was only visited for about four months per year. Bad weather and lack of business for the steamers meant that for eight months St Kilda was cut off from the outside world with no communication. Although the island had a minister and a nurse, serious illness in the winter months often meant death for the islanders. In both 1910 and 1911 famine had struck the island. When the first call of the *Hebrides* or *Dunara Castle* was made in late April, each year the master of the ship was sometimes unsure as to whether there would be any villagers to welcome them. This was the story of St Kilda until a wireless station was built just before the First World War.

Both *Hebrides* and *Dunara Castle* carried tourists during the summer months. The seven day round journey cost £9 (or £10 if a call was made at St Kilda), with meals included in the price, and tours could start from either Glasgow or Greenock. Each ship weighed about 500 tons and could carry approximately fifty passengers. Some of these were Highlanders returning home to one of the many ports of call across the Highlands and Islands. Others were tourists, attracted by the remoteness and beauty of the Scottish islands. Some, encouraged by the travel books written about the Western Isles, particularly Norman Heathcote's *St Kilda* and Richard and Cherry Kearton's *With Nature and a Camera*, made the journey in the same way that modern day tourists travel to far flung parts of the world; to see a way of life and wonders of nature unavailable at home. St Kilda, at the time, was the remotest occupied part of Britain, it had the highest sea cliffs, was home to a variety of birds and animals that were unseen elsewhere in Scotland and also home to a small band of people, known simply to the tourists as 'natives', who had learned to survive on this island at the edge of the world. These 'natives' had lived on St Kilda for centuries, had developed a way of life that was simple and god-fearing and that was at odds with the rest of Britain and that was what the tourists came to see. The tour from Glasgow must have been an exciting one, what with the contrasts from the industrial Lowlands to the calm tranquillity of the Western Isles.

In the compilation of this book I have collected together other period images to go with the photos of the tour, showing the sights and scenes that would have been seen on the *Hebrides'* route from Glasgow's docks down the Clyde and onwards on a tour to the Western Isles and the 'lone sentinel' of St Kilda. The quotes come from the brochures published by both McCallum and Orme for the tours by the *Hebrides* and the *Dunara Castle*, while the brochure pages illustrated are those for the *Hebrides*.

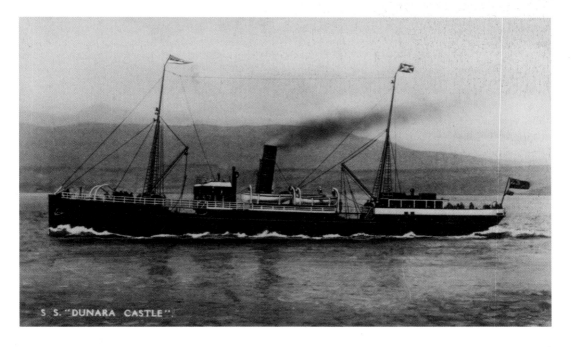

The Dunara Castle, *as seen on a 1910 company-issued postcard. Views like this were most likely sold on board to the intrepid tourists who travelled with Martin Orme from Greenock to St Kilda and the Outer Hebrides.*

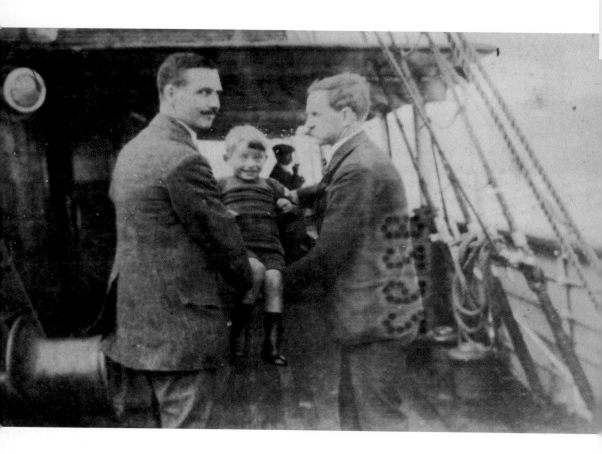

At the time of this tour Glasgow and the Clyde were synonymous with shipbuilding and the excited tourist would have passed some of the largest ships in the world under construction. In 1912 the tourists would have seen the Cunard liner *Aquitania* on the stocks at John Brown's in Clydebank, the largest British naval ships under construction at Fairfield's of Govan and Beardmore's at Clydebank, cargo ships, ferries and small passenger liners at Denny's of Dumbarton, the docks at Greenock and Port Glasgow, a myriad of paddle steamers criss-crossing the Firth of Clyde and then the open sea round the Mull of Kintyre. They would have been in no doubt as to the mercantile and naval might of Britain for they would have seen the evidence for themselves all along the banks of the Clyde. Greenock was the last port of call before the islands and the contrast from bustling port to sleepy island must have been great. Apart from Oban, most of the places visited were small remote villages and hamlets on the coast of numerous islands, with only a weekly call by steamer as their point of contact with the outside world.

With road transport and a series of ferries now serving the Western Isles, journey times in this remotest part of Scotland can now be considered in hours rather than days. It was all so, so different in 1912 as the following pages will show.

Circular Tours to the Outer Islands by the Hebrides

Notice to Passengers.

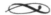

DURING the Summer months Passengers are recommended to book their berths in advance, stating particularly whether the berths are required for Ladies or Gentlemen, and giving the name of each Passenger.

Passengers must take charge of their own Luggage.

All Passengers and their Luggage are carried subject to the conditions stated below and on their tickets and also to the conditions in the Company's Sailing Bill.

The Owners of the Steamer are not liable and/or responsible for loss of life or injury to Passengers nor for loss of or damage to their luggage from whatsoever causes arising nor for loss or delay in any circumstances nor for Steamer not sailing as advertised.

Every ten days at 11.00 a.m. the SS *Hebrides* left Glasgow bound for the Western Isles on a seven- or eight-day journey that would see her call at somewhere between twelve and fifteen separate islands from Islay to Lewis. The *Hebrides* was built in 1898 by the Ailsa Shipbuilding Co. of Troon, weighed 585 tons gross and was owned by John McCallum & Co. of 87 Union Street, Glasgow. She was fitted with triple expansion engines and was capable of 12.8 knots. Her single funnel was painted in the McCallum colours of red with a black top. The black top was both decorative and functional. *Hebrides* was coal-fired and the black top to her funnel did not show the soot that was prevalent with coal-fired ships. The house flag was blue with a white disc bearing a thistle.

Passenger accommodation on board *Hebrides* was for about fifty and the majority of the passenger cabins were in the stern, surrounding the dining saloon, with its two tables. Cabins were also located on the upper deck and bridge deck. Meals on the round journey were included in the price of £10, although if a tour over-ran meals were charged at 9s per day for each extra day that it took for the ship to return back to Glasgow.

In front of the main passenger accommodation was a derrick and cargo hold, with another hold in front of the bridge. Cargo varied from coal, through barley for the whisky distillery at Carbost, cattle, sheep and horses to and from the livestock mart at Oban and all sorts of sundry goods required by merchants and store keepers on the islands visited by the ship. On the return trip were barrels of whisky, tweed and other goods produced for export to Glasgow and beyond.

'There is no pleasanter or more beneficial trip than this week's cruising among the lonely salubrious Isles, around which blow the vitalising breezes from the Atlantic.'

Opposite, top: *Boarding the* Hebrides *the tourist would have been amazed at the variety of ships to be found as far up river as the Broomielaw. They would have had their first clue as to the maritime importance of the river as they looked down onto the docks from the railway bridge entering Central Station. It was but a short journey by carriage to the dockside and on the way the intrepid tourist would have seen ships such as the Allan Line* Mongolian, *shown here. She was on the Glasgow-Quebec-Montreal or Glasgow-Portland-Boston routes from 1906 until war started in 1914 when she was sold to the Admiralty.*

Opposite, bottom: *As well as the cargo and passenger ships sailing up and down river, there were also numerous ferries crossing the river. Here the Govan-Partick Horse Ferry is shown with the shipyard of A&J Inglis behind. The docks were over 2½ miles long and, although the river was once too shallow for large ships, concerted efforts had been made over almost thirty years to dredge and improve the upper reaches of the river to Glasgow.*

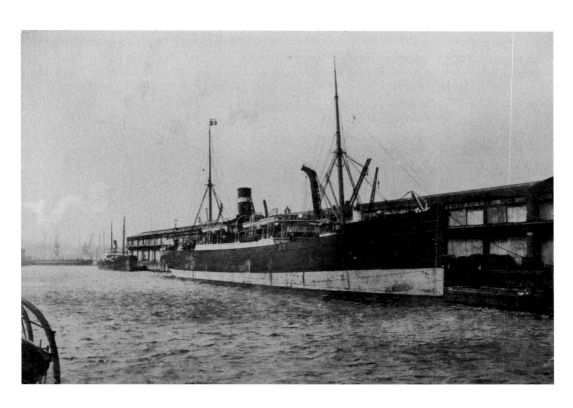

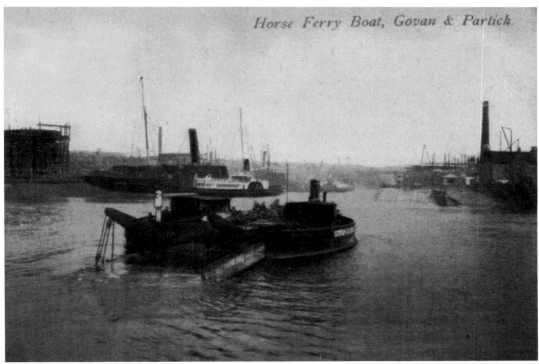

Horse Ferry Boat, Govan & Partick.

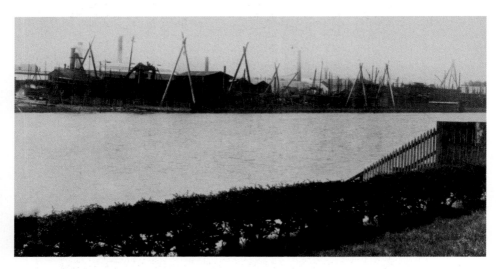

Above: *It would take almost five hours to travel down the upper Clyde to Greenock, in which time the passenger would have passed countless yards building ships of all types and sizes. Here are the yards at Renfrew, which would have included the yard of Lord Lobnitz, who built many dredgers and steam yachts, including the* Wanderer *of 1878, the largest steam yacht of the period.*

Below: *As at Govan, there was also a chain ferry at Renfrew that went to Clydebank. The sender of this postcard in 1912 stated that 'This is the Renfrew Ferry. It will carry two motor cars, two lorries and two small carts with people too at once. It is a big flat boat with engines, and pulls itself along by the chains shown going to the top of the bank.' This double chain ferry was built in 1897 and lasted in service until 1936.*

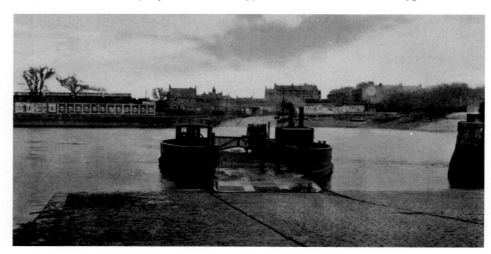

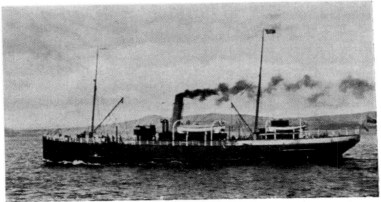

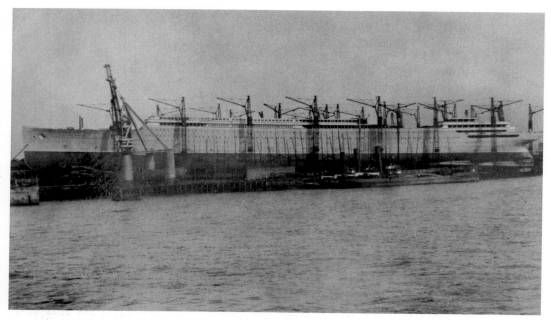

Above: *At Clydebank the passengers would have been amazed at the yard of John Brown & Co. Being constructed here was the largest ship on the Clyde at the time, and one of the five largest ships in the world. The* Aquitania *was the last of the transatlantic four funnelers to be built and is shown here just before her launch in 1913. The* Hebrides *would have fitted inside one of her lounges, such was the size of this Cunard liner. She was to have a long service, lasting until 1950 when she returned to the Clyde to be broken up at Faslane, having served in two World Wars and travelled over one million miles.*

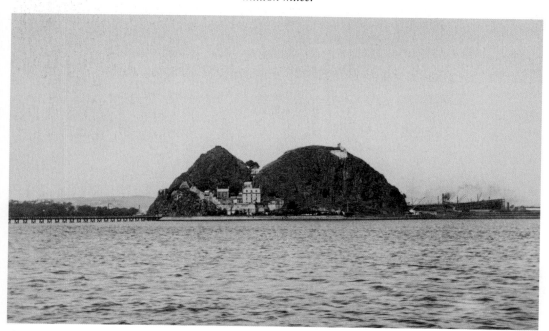

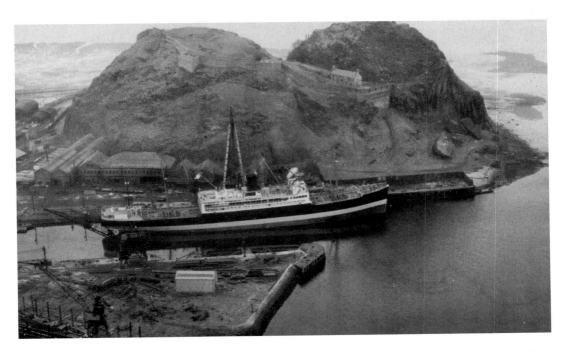

At Dumbarton, the shipyard of William Denny was dominated by the bulk of Dumbarton Rock and its castle. Here the Paddy Henderson liner, Prome, *of that company's British & Burmese Steam Navigation Co.'s line is shown just before she went on her sea trials. Her normal service was Glasgow-Liverpool-Rangoon. Behind is the castle.*

Opposite: *Dumbarton Rock as seen from the steamer.*

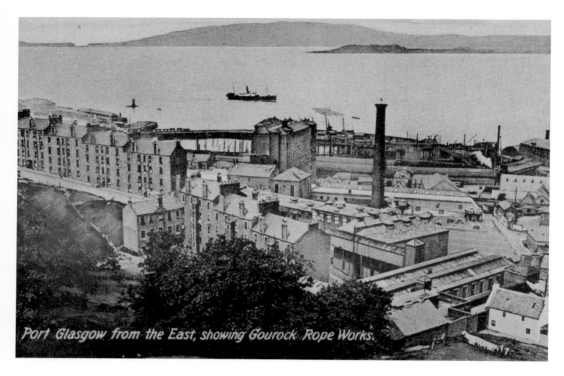

Port Glasgow from the East, showing Gourock Rope Works.

The docks at Port Glasgow were constructed at a time when it was impossible to navigate the Clyde as far as Glasgow. Above is a view looking down to the Clyde with a small cargo steamer passing the harbour. Below is Fore Street with the dock filled with timber.

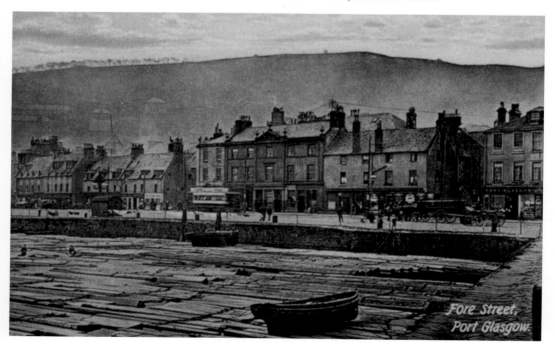

Fore Street, Port Glasgow.

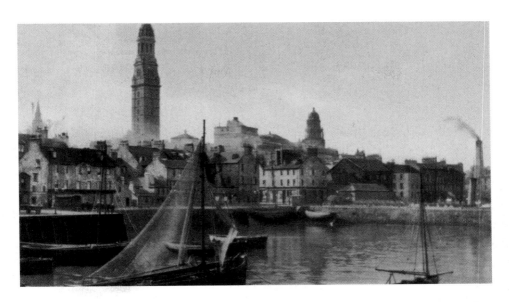

Greenock was a bustling harbour. Its most famous son, James Watt, was responsible for improvements to the steam engine that culminated in its use in ships. Here is the harbour with the tower of the town hall in the background.

'The steamer Hebrides leaves on advertised sailing dates at 4.30 p.m. from Custom House Quay, Greenock.'

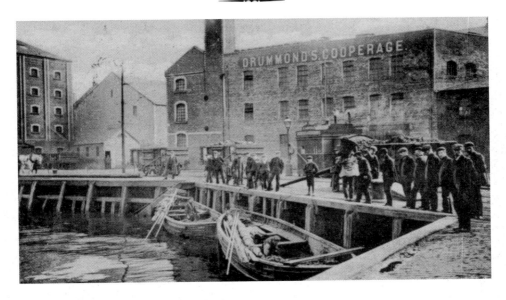

Mussel boats discharging their cargo of shellfish at the East India Harbour, Greenock. Behind is Drummond's Cooperage, which provided barrels for a variety of uses, not least the whisky blenders in Greenock.

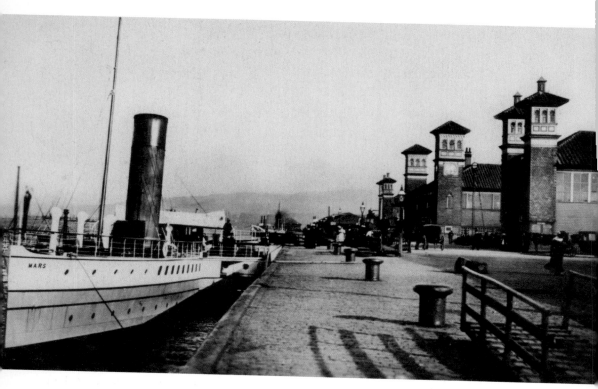

Above: *Greenock, with its Princes Pier railway station, was also a major transhipment point for the Clyde Steamers. With fast trains to Glasgow and a frequent service to the isles of Arran and Bute and to Dunoon, Greenock was an important steamer terminal. The Glasgow & South Western Railway steamer* Mars *was requisitioned by the Admiralty in 1914 and renamed HMS* Marsa. *Used as a minesweeper, she collided with another vessel off Harwich and was sunk in 1918. Princes Pier was also the port of call for the Anchor Line liners.*

ASHTON SHORE, GOUROCK

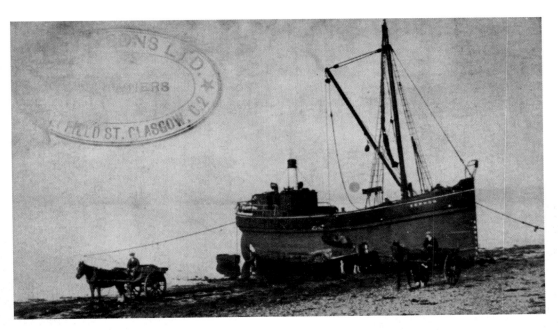

For the islands of the Clyde and the remoter hamlets along its banks, small cargo vessels called 'Puffers' were the preferred form of transport. They could even be found in the Inner Hebrides after having travelled through the Crinan Canal. Some could even get as far as Grangemouth on the Forth & Clyde Canal and many were built in Kirkintilloch, and launched sideways into the canal. They were used for all sorts of cargo and were made legendary by the Para Handy *tales of Neil Munro*.

'The quiet beauty of this district is a contrast to the wild highland shore opposite.'

Opposite: *Going further down the Clyde, the* Hebrides *passed Gourock and the Royal Clyde Yacht Club, shown here on the right. Here was the Tail o' the Bank, where the river Clyde widened out rapidly and became the Firth of Clyde. The Glasgow pilots were dropped off here after taking vessels down the windings of the Clyde. The sea off the Cloch lighthouse was used as one of the two measured miles on the Firth of Clyde and brand new ships could often be seen travelling at maximum speed while on their sea trials.*

Cumbrae Light. This postcard was issued to advertise the Clyde Shipping Co.

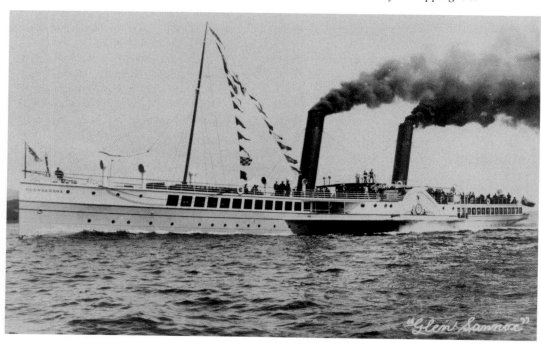

Within the confines of the Firth of Clyde, a multitude of companies ran steamer operations serving the islands of Arran, Bute and Cumbrae as well as the communities along both banks of the Clyde and in the sea lochs of the Gareloch, Loch Long, Loch Striven, Loch Ridden and Loch Fyne. Here is the GSWR steamer Glen Sannox, named after a valley of the Isle of Arran.

Perhaps the most famous paddle steamer ever to sail on the Clyde at the turn of the twentieth century was David MacBrayne's Columba. She was the longest of all Clyde steamers at 301ft and could carry well in excess of 1,000 passengers. Columba was launched on 11 April 1878 at Clydebank and was in service until 1935. Her regular service was from Glasgow to Ardrishaig.

Apart from a short spell during the First World War when her service started at Wemyss Bay, because of the submarine defences from Dunoon to the Cloch lighthouse, Columba sailed on the Ardrishaig route for most of her life. She regularly spent most of the winter months laid up at Bowling as she was too large for the service in the winter. She had a Post Office on board and mail could be franked with a special postmark. Columba also had a hairdressers, a book stall and a fruit stall on board.

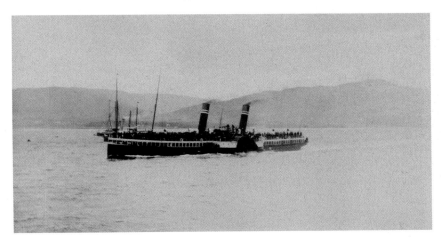

The Lord of the Isles was owned by the Lochgoil & Inveraray Steamboat Co. until 1912 when she was purchased by David MacBrayne and Turbine Steamers Ltd. Here she is on the Clyde in 1898.

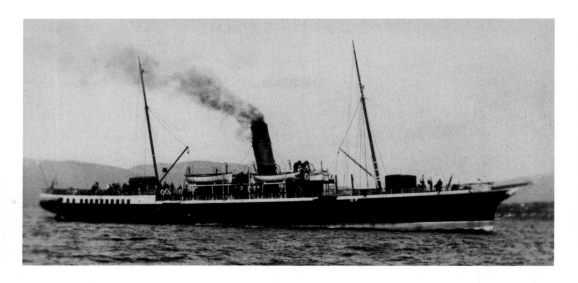

The RMS Davaar of the Glasgow & Campbeltown Steam Packet Co. served the Mull of Kintyre in a similar way to the service of the Hebrides to the Western Isles, carrying all sorts of cargo and passengers, as well as the Royal Mail, to Kintyre from Glasgow. Her captain was P. McFarlane. She was built in 1885 and was scrapped in 1943 after being used as a blockship at Newhaven in Sussex.

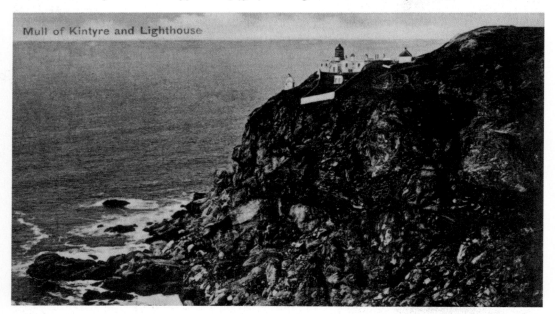

Mull of Kintyre and Lighthouse

The flashing light on the starboard side is the lighthouse at the Mull of Kintyre. Built by the Stevenson family firm for the Northern Lighthouse Board the light is now fully automated.

'That bold, stern headland, the Mull of Kintyre, is passed during the night, and the course is steered north.'

'Next morning early, the vessel passes through the Sound of Islay, a narrow channel 11 miles long, having a rapid tidal current.'

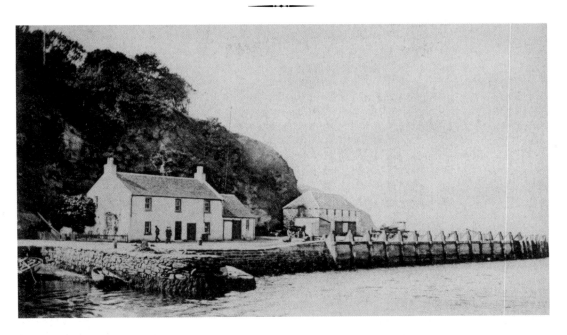

Portaskaig was the first port of call after leaving Greenock.

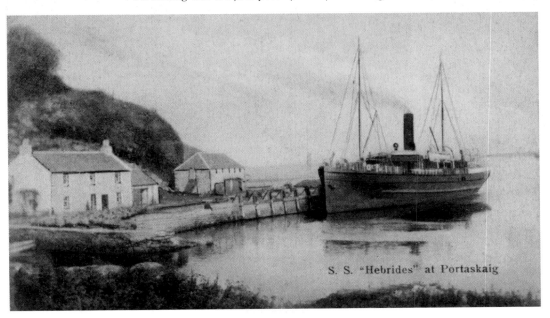

S. S. "Hebrides" at Portaskaig

The Hebrides *at Portaskaig Pier. This was one of a series of postcards sold on board the* Hebrides *and this one was posted from Portaskaig and sent to Bonhill in Dunbartonshire.*

The Steamer entering Portaskaig. Islay

Photo Cameron
Bowmore

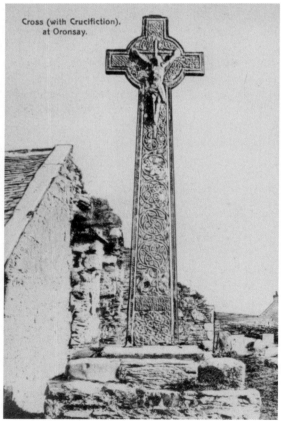

Cross (with Crucifiction).
at Oronsay.

Portaskaig was also the port of call for the RMS Pioneer, *another David MacBrayne ship, built in 1905 by A&J Inglis at Linthouse, Glasgow. She ran the mail service to Portaskaig and Port Ellen from West Loch Tarbert. In 1911-1912 she travelled to Portaskaig two days per week and Port Ellen on the other four. She also called at Jura on the days she travelled to Portaskaig. Her top speed was 14 knots and she was designed with a low draught as West Loch Tarbert Pier was so far up the loch that there is little water there during low tide.*

'The anchor is let go at Colonsay and the landing of passengers and goods for the island proceeds.'

Next port of call was Colonsay, from where it was possible to visit Isle Oronsay. Oronsay is linked at low tide to Colonsay and here there is a fourteenth century chapel. There are many finely sculptured headstones. The Oronsay Cross is considered to be one of the finest examples of Celtic scupture.

To the left of the Columba Hotel were the offices of David MacBrayne. At their steam packet office it was possible to buy tickets for travel to the many islands that the Hebrides did not call at. It was possible to visit Staffa and Iona from here as well as Fort William and the Caledonian Canal. The delights of Oban also included the Oban Distillery, which was in the middle of the town. Above it was McCaig's Folly, built to keep local workers employed in a time of high unemployment. Close by was Dunollie Castle, the Isle of Lismore, Fingal's Dog Stone and the captivating beauty of the Falls of Lora at Connel, where it was possible to see the new railway cantilever bridge and the unique tidal waterfall.

'Passengers have an opportunity of landing and surveying at leisure the beauties of Oban and surroundings.'

The Steamer "HEBRIDES" leaves on advertised sailing dates at **4.30** p.m. from Custom House Quay, Greenock. Those, however, who may wish to obtain a passing view of the famous Clyde Shipbuilding Yards can do so by joining the steamer at Glasgow. Shortly after leaving Greenock (where the voyage may properly be said to begin), Gourock Bay, a favourite anchorage for yachts, is passed. Sailing down the Firth, Gareloch, Loch Long, and Holy Loch, with their magnificent vista of hill scenery, attract attention. A view of the leading watering places is also obtained. The principal places on the right are Kilcreggan, Blairmore, Dunoon with its castle, and Innellan ; on the left (after passing Cloch Lighthouse), Inverkip, Wemyss Bay, and Largs. A little below Innellan the steamer passes Toward Point with its lighthouse, and from here a glimpse may be had of Rothesay Bay, and the entrance to the Kyles of Bute. Leaving the Great and Little Cumbraes astern, comparatively open water is entered. The Island of Arran, with its jagged mountain peaks, among which Goatfell reigns supreme, affords a marked contrast to the long, low

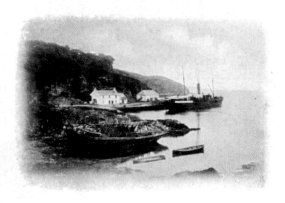

PORTASKAIG, ISLAY.

coastline of Ayrshire stretching southward on the left. By the time the south end of Arran is reached and the revolving light of Pladda shines out, the dim outline of Ailsa Craig may be descried looming in the darkness. During the night the Mull of Kintyre is rounded.

Morning finds the vessel steaming through the Strait between Islay and Jura, the famous Paps of Jura disclosing their rugged forms in varying

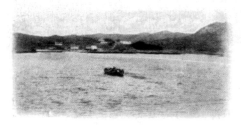

COLONSAY

aspects from the constantly changing points of view. After calling at Portaskaig, the steamer proceeds to Colonsay, which is united at low water to Oronsay (names derived from St. Columba and St. Oran first landing here and establishing their Missionary College before going to Iona) ; thence by the picturesque Sound of Kerrara, Oban is reached in the forenoon. While the steamer discharges cargo here, passengers have an opportunity of landing

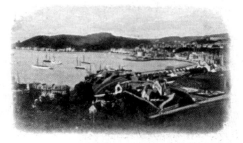

OBAN.

and surveying at leisure the beauties of Oban and surroundings. Passing out of the bay by the north end of Kerrara, the romantic ruin of Dunolly Castle calls for notice, and in close proximity Fingal's Dog Stone may be seen.

Leaving the Island of Lismore behind, the steamer enters Loch Linnhe, and at this point the tourist may indeed realise that he is in the land of Bens; northward, Ben Nevis; eastward, Ben Cruachan, with its twin-peaked summit; and westward, Ben More, in Mull, crown their several ranges. The Sound of Mull opens out to view and affords a continuous panorama of lovely landscapes along its whole length, while "ruined castles old in story" meet the view on every side. The most interesting on the Mull shore are Duart, at one time the chief stronghold of the Mac-

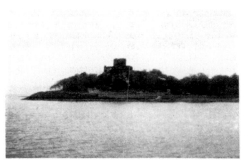

DUNNOLLIE CASTLE, OBAN.

leans, and further on Aros, one of the fortresses of the "Lord of the Isles," where Bruce was once a guest. On the Morven side, Ardtornish awakens interest, the opening scenes of the "Lord of the Isles" having been laid within its walls. On the same side, a little below Loch Aline, Fiunary Manse, the early home of the late Dr. Norman Macleod, may be seen half hidden amidst the trees. The first stoppage after Oban is Tobermory, embosomed in a beautifully wooded bay. It is the capital of Mull, and in former times was an important place, being the nearest market for the outlying islands. Leaving the Sound of Mull, a course is made for Coll and Tiree, which may be seen to the westward.

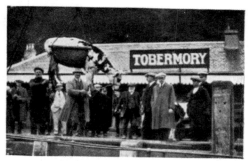

LOADING CATTLE.

Toward evening Tiree is reached, where a tidal pier has recently been erected, which still compels the use of the ferry-boat on occasions. The steamer now proceeds towards Skye, passing the islands of Muck, Eigg, Rum, and Canna. In the early morning the steamer is generally at the entrance to Loch Scavaig, calling at the island of Soay; thence proceeding to Loch Harport, one of the land-locked arms of the sea in the west of Skye, near the head of which stands the famous Talisker Distillery. Carbost is reached in the forenoon. The serrated ridge of the Cuchullin hills rise grandly to the south and show to advantage in the clear air. Emerging from Loch Harport, Loch Bracadale is entered, the steamer then passing in to the Minch. On the left the imposing height of Talisker Head, and on the right "MacLeod's Maidens" and the two lofty plateaux known as "MacLeod's Tables," excite interest. Continuing the course along the north-west

THE GLEN, TOBERMORY

'The first stop after Oban is Tobermory, embosomed in a beautifully
wooded bay. Leaving the Sound of Mull, a course is made
for Coll and Tiree.'

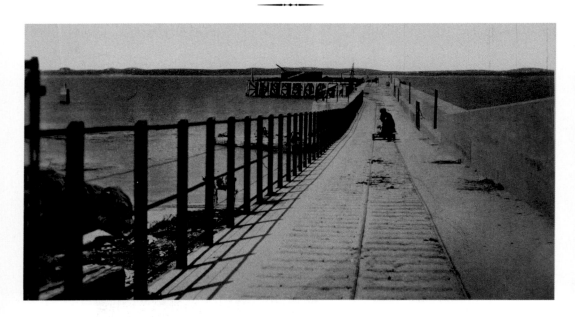

Towards the evening of the second day, Tiree was reached. Here a new pier had recently been constructed, although it was tidal and, as a result boats still had to be used often to transfer passengers and cargo. This view shows the pier constructed at Gott Bay. Note the Highland cow on the immediate left. Below is the island's hotel.

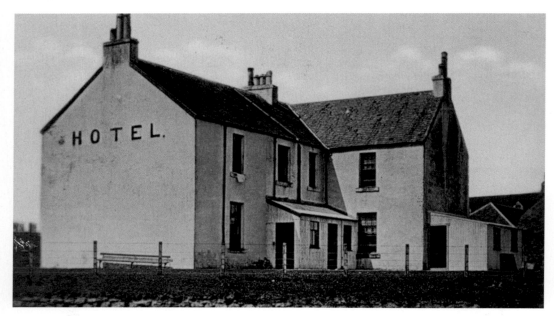

shores of Skye, a call is made at Pooltiel, the steamer afterwards passing the high and rugged cliffs at the entrance to Loch Dunvegan. Rising almost sheer from the sea they admit of a steamer sailing close under their

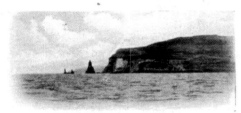

MacLeod's Maidens, Skye.

stupendous heights. Among the numerous caves along the base of the cliffs is one which was the hiding place of Prince Charlie when a refugee in Skye. At Dunvegan, the next port of call, time is allowed for visiting the castle, a privilege granted by the courtesy of its generous proprietor, MacLeod of MacLeod, to passengers by the "Hebrides." Dunvegan Castle is noteworthy as being the oldest inhabited castle in Scotland, and its architectural features harmonise well with its traditions and surroundings. It contains many interesting clan and Jacobite relics. Calling next at Colbost on the opposite side of the loch, the steamer retraces her way and crosses the dark water of the Minch to Loch Eport, or Lochmaddy in North Uist, where the night is passed. (On extended trips to St. Kilda and Loch Roag, Lochmaddy is last port of call before proceeding through Sound of Harris out into Atlantic).

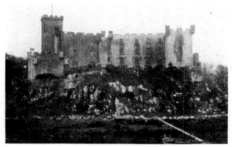

Dunvegan Castle, Skye.

Sailing southward along the shores of the Long Island, calls are made successively at Scotvin and Carnan in Benbecula. "The sea," says M'Culloch, "is here all islands and the land all lakes. That which is not rock is sand, and that which is not mud is bog, that which is not bog is lake, and that which is not lake is sea, and the whole is a labyrinth of islands, peninsulas, promontories, bays, and channels." We next come to South Uist, and after calling at Skipport, Lochboisdale is reached in the afternoon.

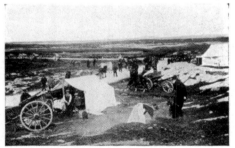

Lochmaddy Market Fair.

Here at Creagorry in Benbecula, and Lochmaddy, are first-class hotels, much frequented by anglers. On the passage to Barra the Sound of Eriskay is passed, where the young Chevalier landed in 1745, vainly

seeking the adherence of the Chief of Boisdale and the elder Clanranald. On the Island of Eriskay a plant grows called the Prince's Plant. Arriving in the evening at Barra, the southernmost point of the Hebrides, the day's run is terminated. On an islet in the bay here stands the ruin of the Castle of the Macneill's, which figures in Elizabeth Helme's "St. Clair of the Isles." At this place the interesting sight may be witnessed during the Herring Fishing of a fleet numbering 700 to 800 boats proceeding to sea.

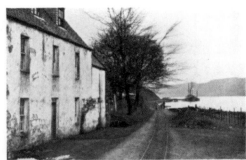

CARBOST, SKYE.

Leaving Barra the steamer makes across the Minch for Tiree, where a view may be had of Staffa and Iona, and the Treshnish Isles. In the latter the fantastic Dutchman's Cap is markedly conspicuous, while Ulva and Mull form a fitting background. After calling at Coll and Tobermory, acquaintance is renewed with the beauties of the Sound of Mull, and Oban is reached in the evening. From Oban the steamer retraces her course via Colonsay and Portaskaig to Greenock and Glasgow.

The foregoing route is subject to any alteration that the Company may find it necessary to make. The Company do not hold themselves responsible for for any delays through strikes, lock-outs, or labour troubles. Passengers for the round may break their journey at any port and complete on a following trip, getting any vacant berth returning, as outward berth cannot be retained.

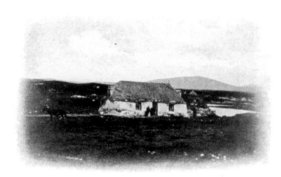

CROFTER'S HUT, LOCH EPORT, NORTH UIST.

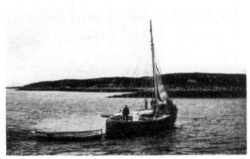

LOCH EPORT FERRY.

Scarinish to St Kilda

. . . Prefatory. . . .

THERE is no pleasanter or more beneficial trip than this week's cruising among those lonely salubrious Isles, around which blow the vitalising breezes from the Atlantic.

The Steamer's course lies through scenes exhibiting the stern wild grandeur of rocks and mountains unsurpassed in lonely and savage magnificence. In some of the places events have occurred that have greatly affected mankind, and romantic and tragic incidents which have caught the fancy and have inspired the pens of the Poet and the Novelist. Artists have found subjects and scope for their brushes in dealing with the wonderful effects in colours peculiar to the atmosphere of the Isles and the display of light and shade, for nowhere do the smiles and frowns of Nature alternate so frequently. Glimpses are to be had of primitive ways of life that are vanishing. Since the remotest times a halo of romance has lain around the Isles. Even the Islesman who goes to live in a foreign land continues bound by the spell of a pathetic love for his island home.

> " From the lone sheiling of the misty island,
> Mountains divide us and the waste of seas—
> Yet still the blood is strong, the heart is Highland,
> And we in dreams behold the Hebrides."

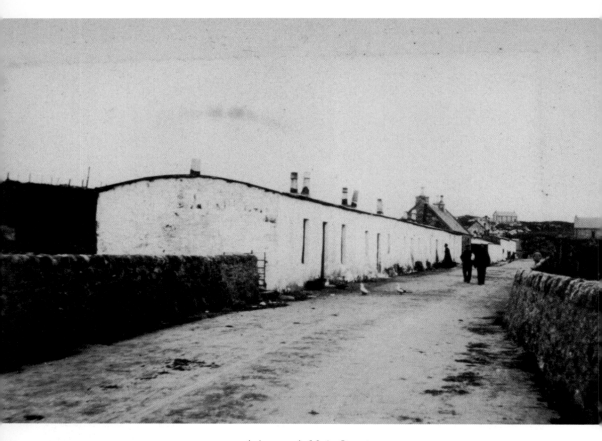

Arinagour's Main Street.

The intrepid tourists had reached Scarinish and it is here that the album begins. It is incomplete as far as the locations of the tour itself goes and is obvious that the photographers kept their precious film for St Kilda itself. There would have been little opportunity to acquire new film among the island ports of call. After Oban the only major town visited was Lochboisdale and, in 1911, Lochboisdale could hardly be called a major town.

Some of the scenes on board the *Hebrides* show the happy tourists on their voyage as well as crew members with their busy loading and unloading.

At Arinagour there was little to see and the photographs confirm this. The first photograph shows a row of houses in the village. At Hynish were those of the lighthouse keepers for Skerryvore lighthouse. Skerryvore is one of the masterpieces of lighthouse design and is a tribute to the design and engineering ability of the Stevenson family, who dedicated their lives to the design and construction of lighthouses along the coast of Scotland. Their work for the Northern Lighthouse Board covers some of the most spectacular lights in the world from Muckle Flugga in Shetland to the Bell Rock at Arbroath and the lights of the Western Isles from Skerryvore to Barra Head. Their fame has been outweighed by that of one member of the family, Robert Louis, whose ill health led him to leave the family firm in Edinburgh and write for a living. His stories are invariably based in and around the locations he visited while away with his father on one of the Northern Lighthouse Board ships.

For the passenger with little time to explore the island, the work of the crew could be just as exciting. The call at each little settlement invariably lasted only as long as there was cargo to load and unload and, as a result, time at each place was limited. There was often little time to go wandering much beyond the pier head. Here a horse is being unloaded by derrick into one of the sgoithean (little ferry boats) used in the West Highlands to transfer cargo and passengers. The tide was obviously out that day as the sgoithean were being used rather than the pier. This would have been the first port of call without a decent pier and the horse was probably purchased at Oban Livestock Market, one of the biggest in the Highlands.

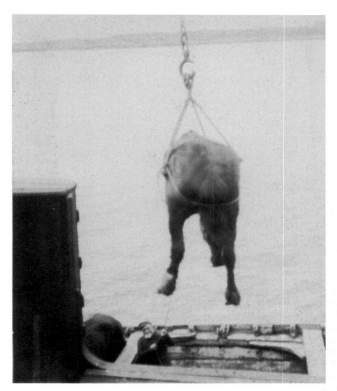

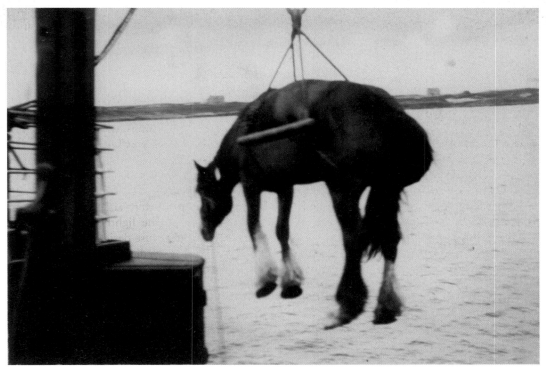

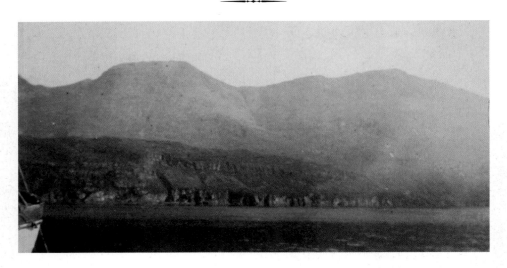

Not long after daybreak the steamer was to be found at the entrance of Loch Scavaig, where it would also visit the island of Soay.

After Soay the Hebrides made her way up the coast of Skye to the land-locked arm of the sea called Loch Harport. Near its head is the village of Carbost where the Hebrides called in the early afternoon. The whisky distillery at Carbost was, and still is, famous for the production of Talisker single malt.

'Having passed through the Sound of Canna, a scene of wild and savage magnificence bursts into view. The majestic Cuillins rear aloft their serrated ridge of gaunt peaks, and show their barren flanks scarred with gloomy cliffs and dark ravines. Away to the north west, for thirty miles stretches the wavy wall of stupendous cliffs forming the west coast of Skye. To the west the hills of Barra and Uist rise from the sea.'

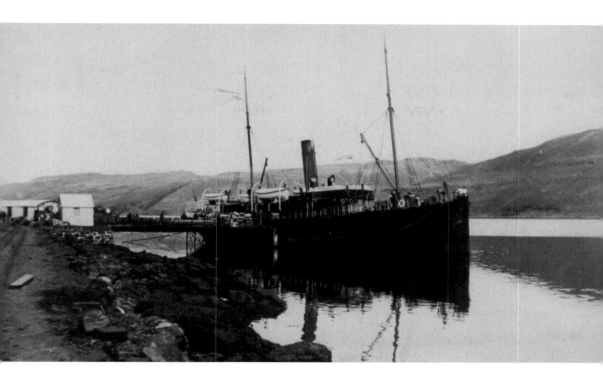

At the time the distillery was one of the regular ports of call, and probably one of the most profitable. It required a steady import of coal, empty casks, barley and other supplies as well as a steady export of aqua vitae. On the pier here it is possible to see whisky barrels by the dozen as well as sacks of barley in prodigious quantities.

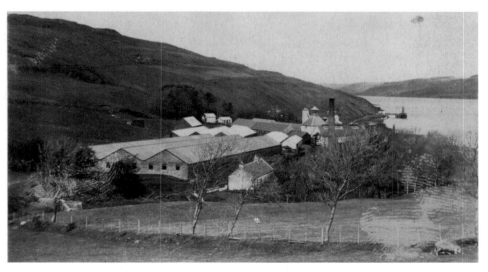

With the loading and unloading at Carbost it was possible to spend time away from the ship. Here one of the intrepid photographers has walked up behind the distillery and photographed Talisker with the pier in the background.

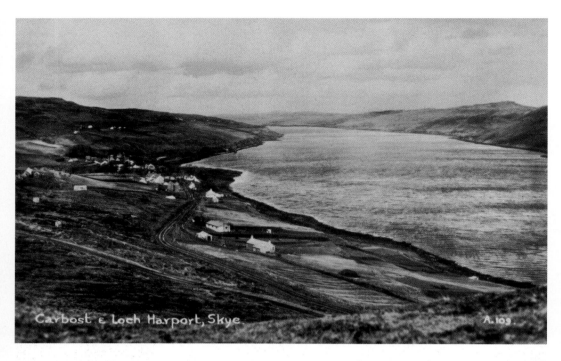

A view of Carbost and Loch Harport showing the small settlement and distillery.

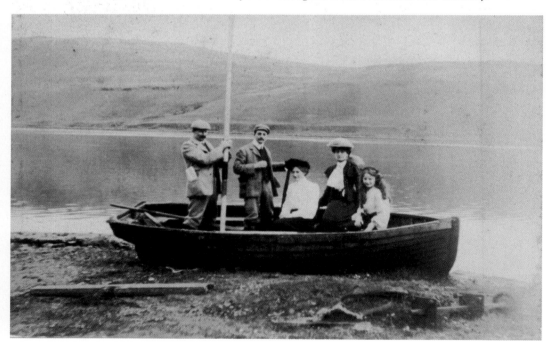

As well as the local scenery it was time to lark around and stretch the legs. Here some of our tourists play around with a small boat next to Carbost.

After loading, the ship would pull slowly away from Loch Harport and enter Loch Bracadale. On the left is Talisker Head and on the right are MacLeod's Maidens and MacLeod's Tables. The Maidens are three pinnacles, or stacks, that soar up from sea level with the cliffs as a backdrop. The contour of the largest resembles a lady wearing a long flowing dress. They are to the left on this view, with the two plateaux of MacLeod's Tables directly in front of the camera.

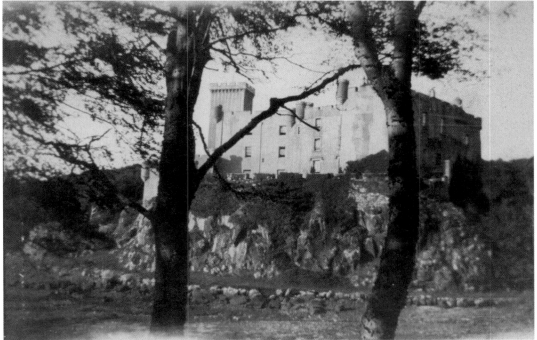

Once in MacLeod country, the ship travelled to Dunvegan, home of MacLeod of MacLeod, the clan chief. Dunvegan is reputedly the oldest inhabited castle in Scotland and has been home to the MacLeods for centuries.

'At Dunvegan, the next port of call, time is allowed for visiting the castle.'

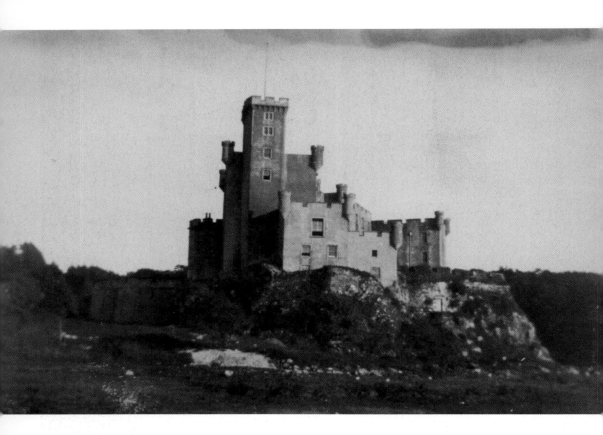

Seen from the ship on passing to the pier, the castle on its rocky perch has a very imposing appearance. The present building comprises additions made at different periods and the date of the oldest part is lost in the sands of time. In the days of tribal feuds the castle was witness to many dark deeds. One of the most vile was at Trumpan, on the way to Uig. At Trumpan Church, a congregation of MacDonalds while in worship, were burned alive when some MacLeods set fire to the church.

Opposite, below: *Within the castle are many interesting relics including the most famous, pictured here: the Fairy Flag which has supposedly mystical powers, Rory More's drinking cup (which by tradition each Chief is expected to fill with claret and drink at one draught) and the horn. Rory More's sword is also one of the artefacts still to be seen today at Dunvegan.*

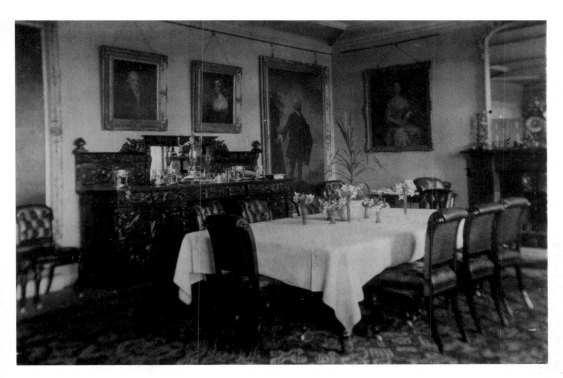

The dining room within Dunvegan Castle.

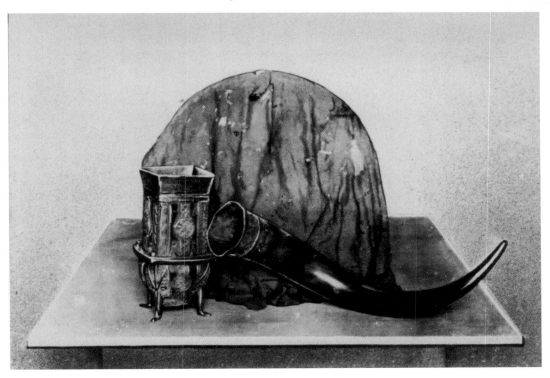

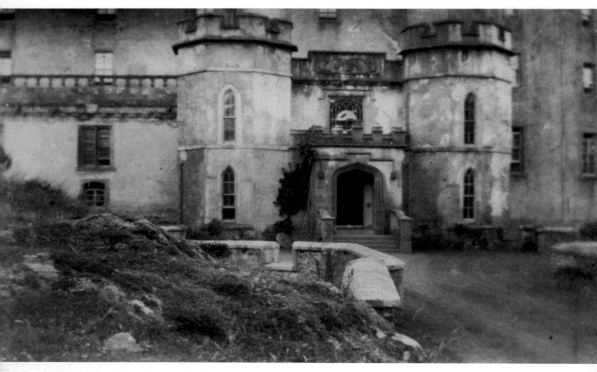

Above: *The entrance to Dunvegan Castle. As well as the aforementioned artefacts, there are also mementoes of the visits of Dr Johnson, Boswell and Sir Walter Scott.*

Left: *The glen at Dunvegan was a tranquil spot in stark contrast to the castle with its dastardly past.*

Opposite: *The Steamer called at Colbost on the opposite side of the loch, then crossed the Minch in twilight as she sailed for Lochmaddy in Uist where she spent the night. After Lochmaddy, the ship then sailed out into the Atlantic bound for St Kilda.*

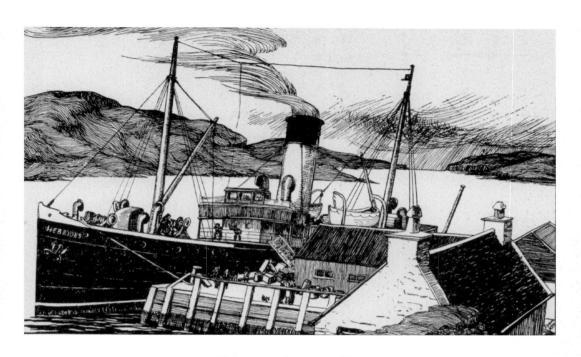

Hebrides *at Dunvegan Pier.*

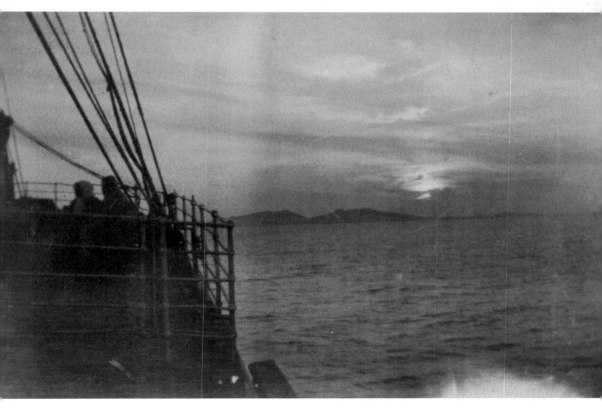

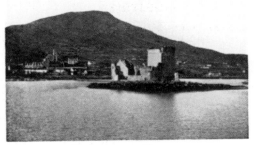

CASTLEBAY, BARRA.

ST. KILDA.

SITUATION.

THE ISLAND OF ST. KILDA rises like a " lone sentinel " from the tempestuous waters of the North Atlantic, about 50 miles to the west of Harris. Being thus open to all the storms which visit that quarter, it is only during the summer months of the year that any communication can be made with it from the mainland, and practically it is cut off from September to May. Properly speaking there is a group of islands comprised under the above name, the principal one being called by the natives Hirta, and the others Dune, Soa, and Boreray.

SCENERY.

THE Scenery is of a wild, rugged nature, sheer cliffs rising to stupendous heights from the sea, these being covered by myriads of sea birds. A few of the islands have a scant pasturage, but for the most part they are mere bare, barren rocks.

VILLAGE AND NATIVES.

HIRTA, the largest and only inhabited island, has been compared to a leg of mutton in shape. The village is here built on sloping ground not far from the shore, and is backed by lofty hills. It consists of sixteen stone cottages, built in a crescent shape, and three better houses and the church. This latter originally belonged to the Established Church of Scotland, but it was afterwards taken possession of by the U.F. Church party. It is a plain-looking building, and is without flooring. A ship's bell, picked up from the shore, serves to call the faithful to their devotions. The natives, who number about seventy, are a strong, hardy race, though rather under medium height. These occupy the cottages, while the better houses are those of the minister and the store. Behind the village is a small graveyard, enclosed by a loose stone wall.

LIVELIHOOD.

THE Islanders live principally on mutton, seafowl and their eggs, potatoes, oatmeal porridge and cakes, cheese and milk. Fish, though to be had in plenty and variety—there being ling, cod, halibut, skate and conger eels—they do not often eat, as they say it brings on an eruption on the skin.

INDUSTRIES.

THE St. Kildians are very industrious. The arable land is altogether only about twenty-two acres, enclosed by a wall, and this is divided into plots on which are grown barley, oats, potatoes, etc. Of domestic animals they have cattle, sheep, dogs, and cats. There are no horses on the island. Their sheep they do not shear, shears being unknown, but " pluck " the wool off. This is spun by the women and woven by the men into a coarse grey cloth. As agriculture, &c., takes up a small portion of their time, the principal occupation of the islanders is the catching of sea birds, for the sake of their feathers and oil, these being bartered with the factor for the proprietor— Macleod of Macleod—in payment of rent. The variety of birds are solan geese, fulmars, guillemots, razorbills, and puffins or sea parrots. The island of Boreray, which rises sheer from the sea, to the height of 1,250 feet, and two immense rocks near it, are the home of solan geese. These come here in March and leave in October. They are caught by the natives in the dark, but it is rather a difficult process, as the geese have always a sentinel on the lookout for intruders ; once this sentinel is disposed of, the other birds seem paralysed and are easily caught. It is estimated that these birds devour 214,000,000 herrings a year, which is equal to 305,715 barrels—more than the total average of herrings barrelled on the whole of the north-east coast of Scotland. St. Kilda is the only part of Great Britain in which the fulmar breeds, although it is sometimes seen in Shetland. It is said to feed on the blubber of live whales, porpoises, &c., and has a most offensive smell, which pervades every part of it, flesh, feathers and all. The principal mode of catching these is for the fowler to be slung over the edge of the cliffs by a rope round his waist, the end of which is held by those at the top, who lower and raise him as required. He has a long rod with a noose at the end, which he passes over the heads of the birds and then affixes them to his girdle. After the catch is collected it is divided among all who have partaken in the labour, fowlers and those who have been attending on them. The water being very deep close round these rocks admits of one sailing almost under them, and when you try to look to the top you have to lean right back, and the height seems far greater than it really is. On raising the birds by firing a gun, or otherwise, they fly around in thousands and literally darken the sky, in fact it has been said to " beggar description."

PECULIARITIES.

ONE of the most peculiar things about the St. Kildians is, that they invariably catch cold whenever strangers visit the island. The illness is often called the Harris colds. It is a kind of influenza, and the natives say that when a steamer or yacht comes from Glasgow or elsewhere, the attack is not so severe as when the factor's smack from Harris visits the island. It is stated that the only similar condition of matter, traceable, all over the world, is to be found at Tristan-da-Cunba, a solitary island in the South Atlantic Ocean. Another peculiarity which may be mentioned is the great infantile mortality through lockjaw, or, as it is called by the St. Kildians, " eight-days sickness." This disease has afflicted St. Kilda for over a century at least. Macaulay, writing in 1758, says the infants born on the island were then peculiarly subject to it. The symptoms at that time appear to have been much the same as the present day, as he says, " On the fourth or fifth day after their birth many of them gave up sucking ; on the seventh their gums are so clenched together that it is impossible to get anything down their throats ; soon after this symptom appears they are seized with convulsive fits, and after struggling against excessive torments till their strength is exhausted, die generally on the eighth day." So great was the dread the islanders had of the ravages of this disease, that a mother seldom thought of providing clothing for her babe until she saw whether it survived the first few crucial days. Various are the conjectures as to this terrible scourge, such as intermarriage ; but careful nursing, taught by a trained nurse sent to the island some time ago, has done much to lessen the mortality and the dread.

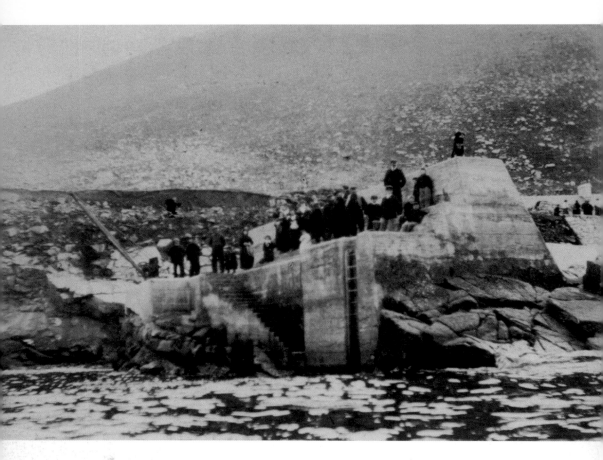

After arriving at St Kilda early in the morning, the Hebrides *dropped anchor in Village Bay. The transfer to the pier involved using the ship's boats and the boats of St Kilda, which numbered four, and were owned by the entire population. By the time the boats were rowed to the pier a huge crowd of St Kildans would wait expectantly for the passengers and mail. Almost all of the villagers would run to the pier and await the visitors. Almost thirty villagers await the boat with one of the island dogs at the head of the pier. One boat has already arrived and some of the villagers are already walking back to the village with the new arrivals. The concrete jetty was constructed in 1901 and cost £600. The carrying of goods to the village was delegated to the women, the men carrying them from the ship in the small boats. If they began to pile up, there was much haranguing and shouting as the goods were removed from the pier. Before the pier was built, boats were landed on the rocky foreshore and goods carried over the wet, slippery rocks to the village.*

*'The island of St Kilda rises like a 'lone sentinel' from the tempestuous
waters of the North Atlantic, about fifty miles to the west of Harris.'*

———— •◦• ————

*The Post Office was opened in 1900 in one of the rooms of the Manse and the first postmaster was
the Revd Angus Fiddes. In May of that year the brass mailbag seal and hand stamp arrived by steamer
and by July the Post Office was fully operational. By the time of this photograph in 1911 or 1912
the postmaster was Neil Ferguson, the only native St Kildan to hold the post. He had taken over as
postmaster in December 1906 and, as well as being the factor's representative on the island, retained
this role until the island was evacuated in 1930. Outside the Post Office are a mixture of tourists
and natives; the locals awaiting their first contact with the outside world for months, and the tourists
buying souvenir postcards and island crafts to prove to their friends that they had visited Britain's
loneliest island. In an island short of such simple things as panes of glass, one of the windows of the
Post Office is boarded up and there are two postcards or photographs for sale in the other windows.
Five of the intrepid tourists are talking to an islander at the entrance to the Post Office.*

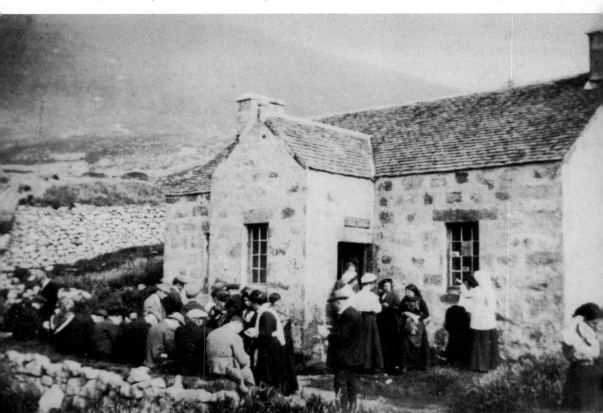

ST. KILDA.

St. Kilda. The Steamer goes occasionally to this remote group of Islands which are situated in the Atlantic about 50 miles west of Harris. The aspect of these Islands with their abrupt peaks and the stupendous cliffs in some places rising almost perpendicular from the sea to a height of 1,300 feet, is most imposing. The population consisting of a few families is congregated in a village close to the anchorage. The St. Kildans are most expert fowlers, they go over the cliffs suspended on ropes and capture sea-birds and collect the eggs, both birds and eggs are used for food. Many of the eggs, some very beautiful, are blown and sold to visitors. The St. Kildans also sell homespun cloth which they make from the wool of the native sheep. It is a most interesting, primitive community.

Left and opposite: *How the companies sold the tour to St Kilda in 1912.*

Below: *Landing stores before the concrete jetty was constructed. The men rowed the boats to the ship in the bay and the women carried the stores to the village.*

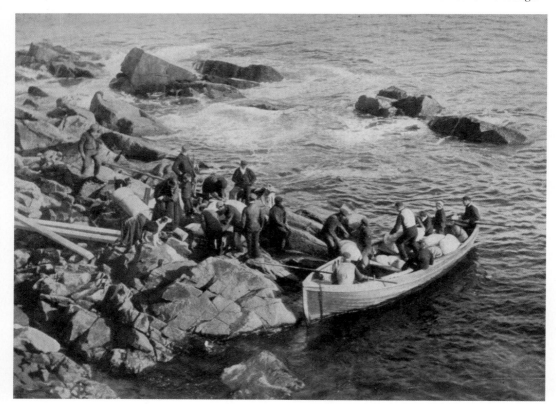

Annual Cruises to St. Kilda

ON SPECIAL DATES

FARE FOR THE TRIP (BOARD INCLUDED),

£10

Berths in Four-Berthed Room, 2/6 extra; in Two-Berthed Rooms and Deck Cabins, 5/- extra; and Passengers remitting by own Cheque (London excepted), will please include cost of exchange.

The Tour occupies about 7 days, but any meals supplied beyond 8 days to tourists will be charged at the rate of 9/- per day.

EARLY BOOKING ADVISABLE.

STEWARD'S RATES:

Breakfast,	3/-
Dinner,	4/-
Tea,	3/-

FIRST-CLASS CUISINE.

St. Kilda—Cliffs, 1,250 Feet High.

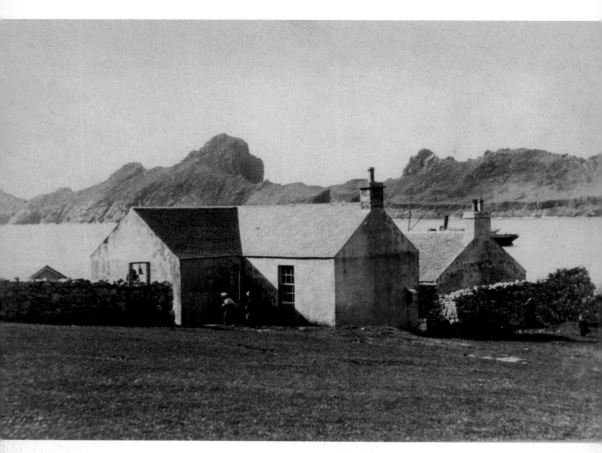

Behind the manse and Post Office was the church, which was built in 1829 by the Society in Scotland for the Propagating of Christian Knowledge. The church was a plain building only eighteen feet long and thirteen wide inside, with four Gothic-style windows and a slate roof. The extension on the church shown here was the schoolhouse, which was started in 1897 and finished in 1899. The large windows were necessary as any teaching could only be done in daylight and the two windows of the schoolroom allowed the maximum amount of light. Originally one room of the factor's house, the only two-storey building on the island, served as schoolroom. The church bell, located to the left, was actually recovered from the shore in the 1860s and was a ship's bell from a vessel wrecked just offshore.

Looking up the Village street, showing the houses built in the 1860s. There were sixteen cottages, all 33ft by 15ft internal size, and they were constructed by the MacLeod master mason, John Ross. Each home could boast two hearths, one at each gable, and the walls were thick, to keep out the winter wind, snow and rain. Each house had two windows, one for each room and the roofs were originally constructed using zinc sheets. After a harsh winter the zinc sheets were swept away and were replaced with felt, nailed and stapled, wired to the masonry and then covered in pitch. Each house was built about twenty yards from its neighbour and they comprised the only street in the Western Isles at the time. In fact, the street was named Main Street and the houses numbered from No.1 (closest to the manse) to No.16.

The islanders owned Border Collie type dogs, used for sheep herding, and there were dozens of them on the island. While still puppies the dogs had their teeth broken or filed down so that they would not damage the sheep while herding them.

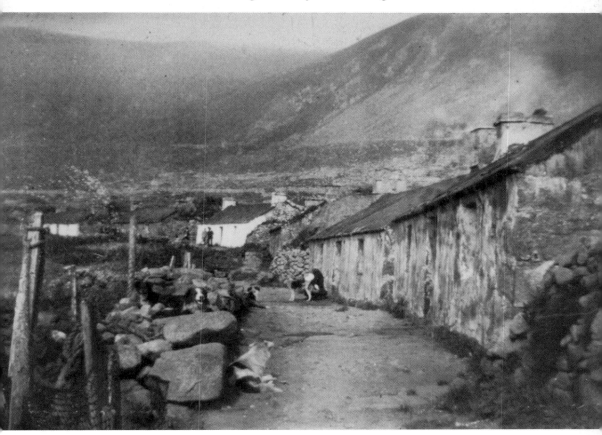

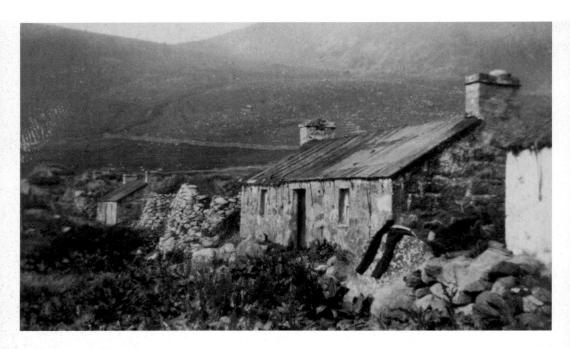

Looking further up the street, with a pair of trousers drying on the drystone dyke. In front of the houses was a stone slabbed pavement, constructed mainly to provide a good run-off for rainfall and to ensure that no mud entered the houses from the street when it rained.

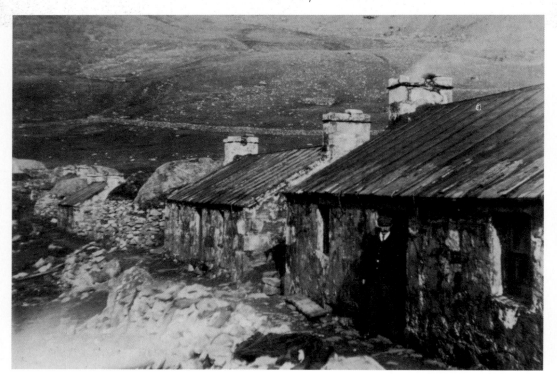

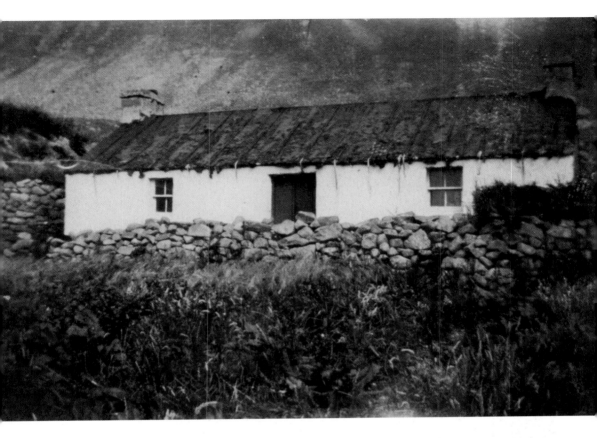

The front of one of the cottages, this one is one of only two or three whitewashed houses on the island. Next door is one of the original 'black houses', the traditional Hebridean cottages that provided accommodation before Main Street was constructed.

Opposite: Neil Ferguson, the factor's representative, stands outside one of the doorways to a village house. Ferguson was probably the richest man on the island, being paid by the Post Office and by MacLeod of MacLeod, the owner of the island. Each of the houses was divided inside into two or three rooms using wooden partitions. Two rooms would be used for living in and the third smaller room had beds for the occupants.

—◦◦◦—

'The scenery is of a wild, rugged nature, sheer cliffs rise to stupendous heights from the sea.'

—◦◦◦—

Overleaf: Looking down on to Village Bay from above the village with the Hebrides in the bay. In front of the houses are some of the villagers' fields and in the background are the jagged peaks of the island of Dun.

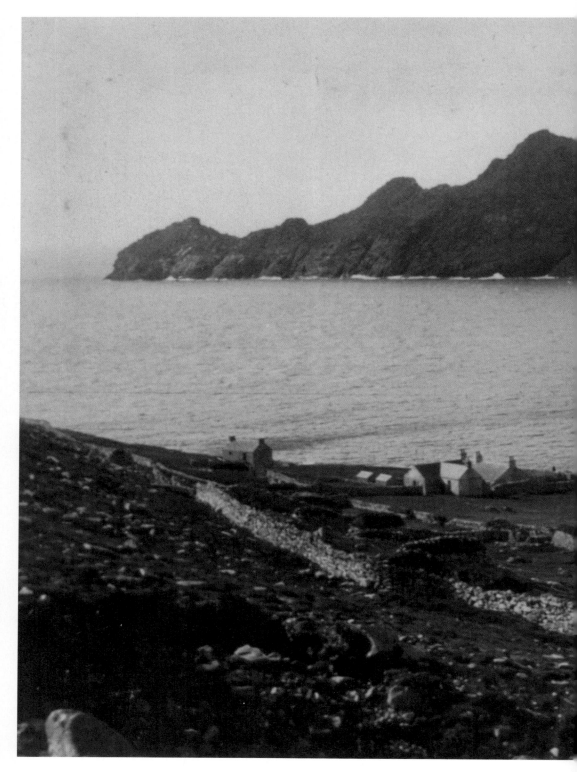

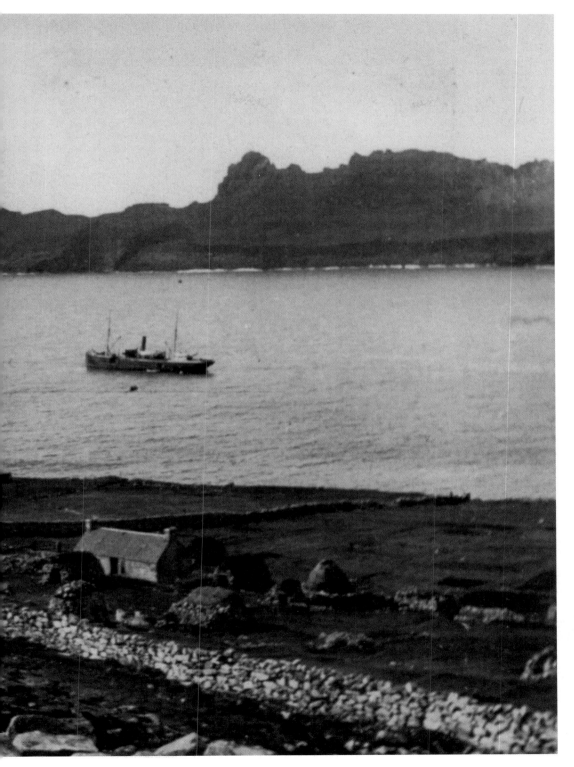

Opposite: The 'Fairy Cave' is evidence of occupation on the island from at least a millennium ago. This house was excavated by Richard and Cherry Kearton in 1898 and is 30-40ft long and about 4ft square. It has another tunnel running off at right angles to a length of 10ft which was probably used as a bedchamber. Inside the house were found many shards of earthenware pottery and implements, including whetstones, hammer stones and rubbing stones, as well as a Viking-period iron spear head.

'Behind the village is a graveyard, enclosed by a loose stone wall.'

The dead of the village were interned in the graveyard. Neil Ferguson related that 'when anybody died all work stopped, nobody worked for a week, and they used to have a wake there every night until he got buried.' Although the graveyard was small it had seen more than its fair share of burials. As space was required some bodies were exhumed and the space used for new burials. During the nineteenth century many new born babies died on the island from tetanus, a disease that was not eradicated until the 1890s when a nurse came to the island and changed the habits of the womenfolk at childbirth, helping to prevent tetanus in the newborn child.
The wall around the churchyard served a double purpose. Firstly, it kept the livestock and dogs out, preventing them digging up the bones, and, secondly, it allowed the build up of earth within so that the islanders could bury the dead properly.

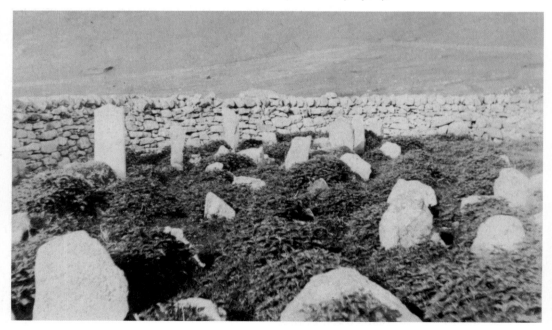

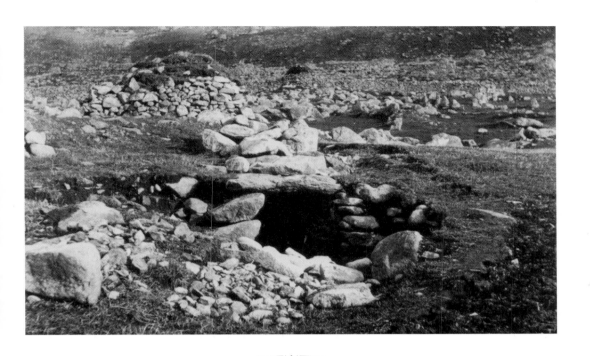

'The population consisting of a few families is congregated in a village
close to the anchorage.'

Below: *This view gives a good idea of the size of the village, showing almost all of it from the rear.*

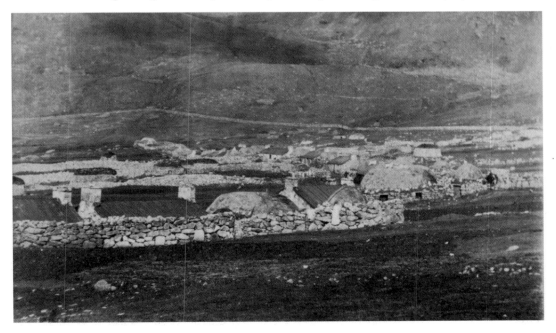

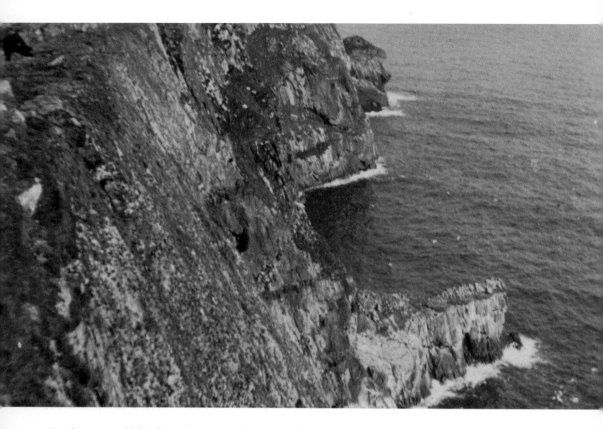

Fowling, or wild bird catching, was the principal activity of the natives. St Kilda was, and still is, one of the great sea bird habitats of western Europe. The islands also have the highest sea cliffs in Great Britain at over 1,250ft high. To catch the fulmar, the men would go down the cliffs on horsehair ropes and catch the birds with a noose on a pole. To catch the solan geese they would dispatch the sentinel, or watch bird, and then catch many more at night. The meat, oil from the gut and feathers were all used or bartered with the factor to pay the rent. Here, two men are giving a demonstration of fowling and of their bravery as they dangle hundreds of feet above the waves below.

A fulmar and a puffin, stuffed and on display somewhere in the village, probably in the manse or factor's house.

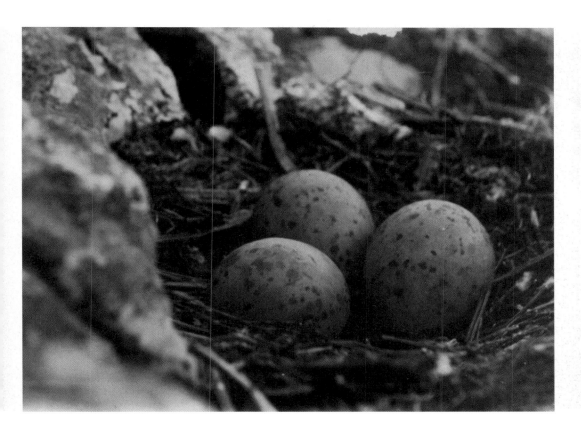

The nest of a St Kilda Wren, a breed of wren native only to St Kilda. It is slightly larger than the mainland wren and the eggs are also slightly larger.

'Many of the eggs, some very beautiful, are blown and sold to visitors.'

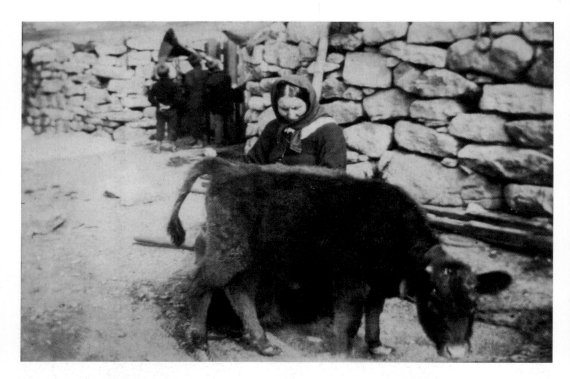

A native woman milks one of the few possessions of value that the islanders owned – one of the thirty or so cattle on the island. In 1877 a visitor stated that the herd consisted of one bull, twenty-one cows and twenty-seven calves. The cattle were smaller than the mainland variety and their meat reputedly tasted very sweetly. Behind, three native boys look in amazement at a gramophone, brought onshore by some of our intrepid tourists.

'It is a most interesting, primitive community.'

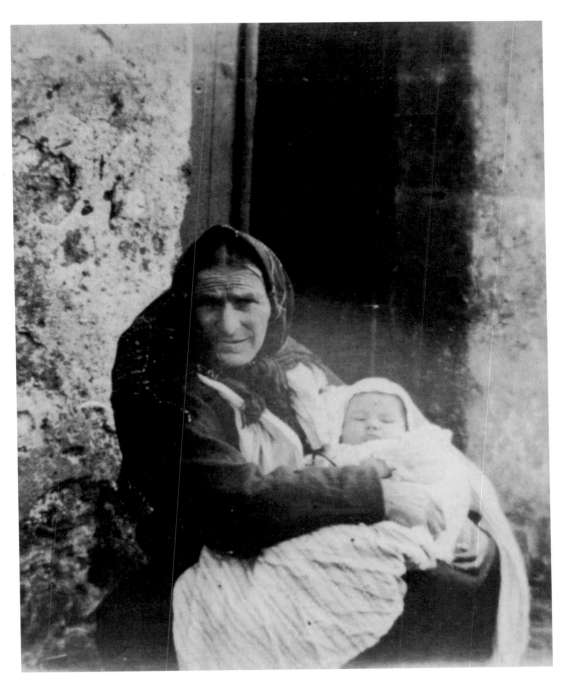

A native woman with her child outside one of the houses on Main Street. This woman, with her weather beaten face, is probably about forty. Most clothes at this time were made by the St Kildan men, even those for the women. They skilfully turned out the womens' dresses but most of the accessories, especially the turkey-red napkins (turkey-red dye was invented in the Vale of Leven in Dunbartonshire), bonnets, caps and scarves were imported from the mainland.

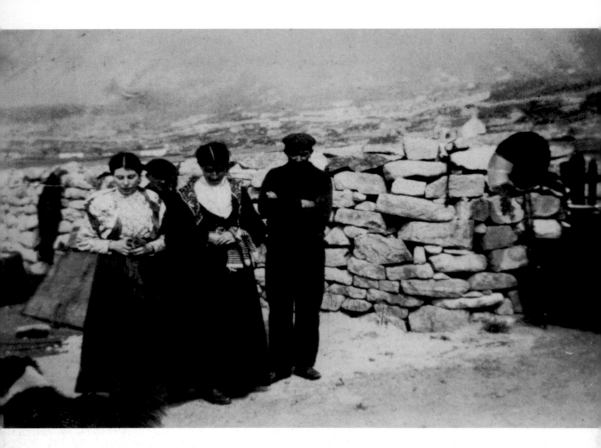

Two native men and two women listen to the gramophone. Hits of this time included Alexander's Ragtime Band *and* Nearer, My God, to Thee *(made popular after the sinking of the RMS* Titanic *in April 1912). What the islanders, many of whom had never left the island, made of the hit parade of the time will never be known.*

Some of our tourists and natives look on as a new selection of records is made.

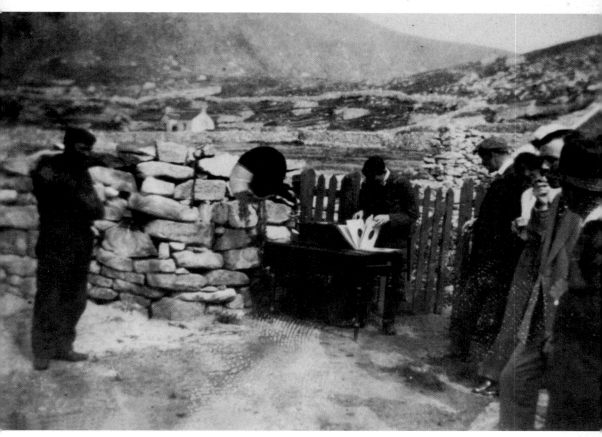

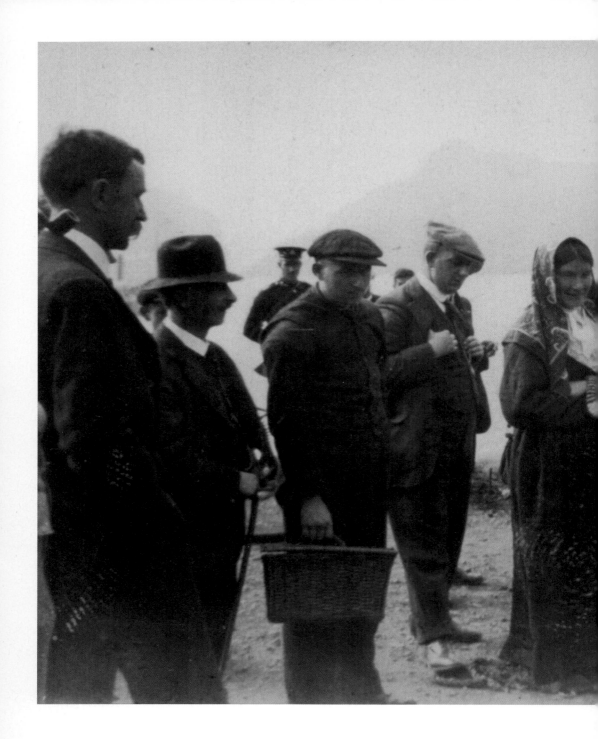

In the background of this view is a policeman, making his yearly call to the island. Crime was unheard of on St Kilda but the local bobby (from Uist or Harris) still made his rounds. The native women rarely had knitting out of their hands and this woman is no exception. She is making another pair of St Kildan stockings, sold to the tourists, as well as exported to Glasgow for sale there.

Here lollipops are being handed out to the native children by the factor, meaning that this was most likely the first Hebrides visit of the year. He would have then spent many hours bartering with the natives for their accumulated goods including knitwear, feathers, fulmar, gannet and puffin oil, tweed cloth and dried, salted gannet which was known as guga.

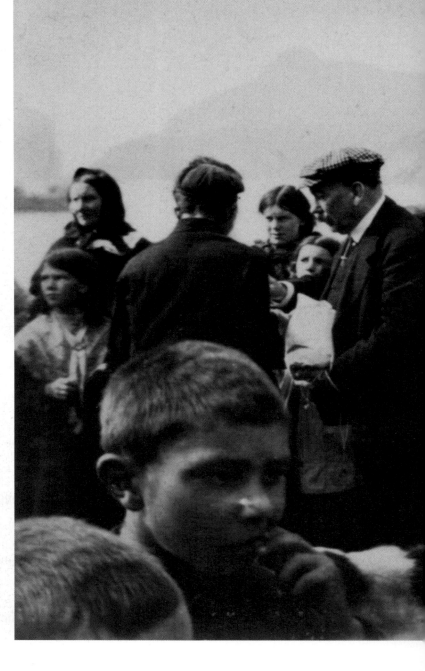

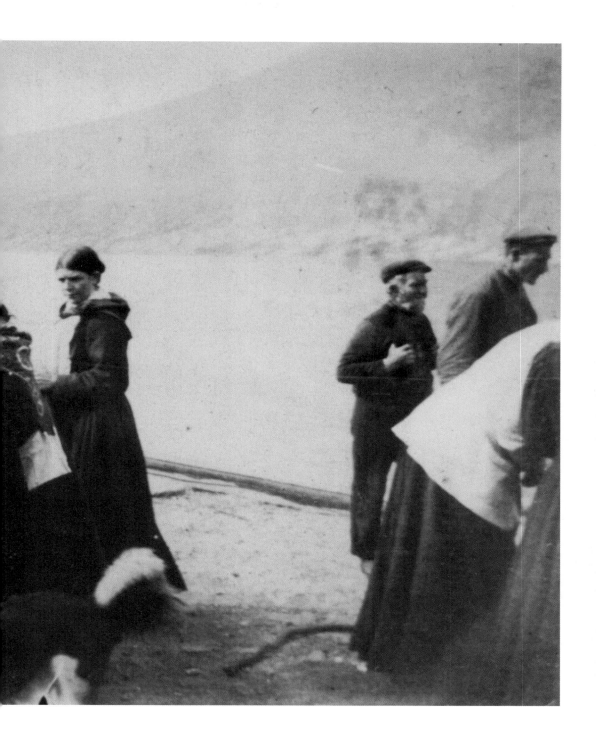

Opposite, above: A Cherry Kearton image of the foot of the cliffs on Boreray. The men have been fowling, some have birds round their necks and others the horsehair ropes used for cliff-climbing and nooses for catching the fulmars and gannets.

Opposite, bottom: One of the postcards of St Kilda issued by George Washington Wilson in Aberdeen. This one is of gannet's nests. The images from this series of postcards were taken in 1886 and the way of life had changed little by the time of evacuation in 1930.

Below: Stac Biorrach. St Kilda's stacs are the highest in the UK and rise spectacularly out of the waves.

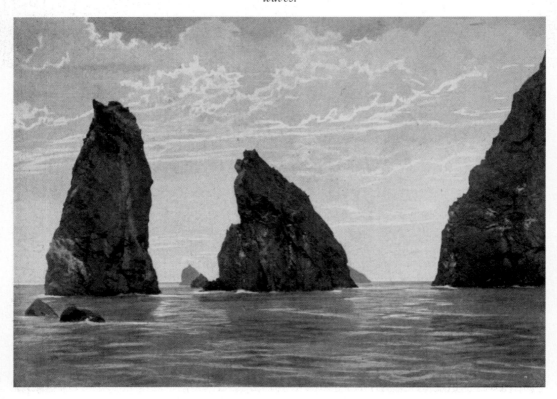

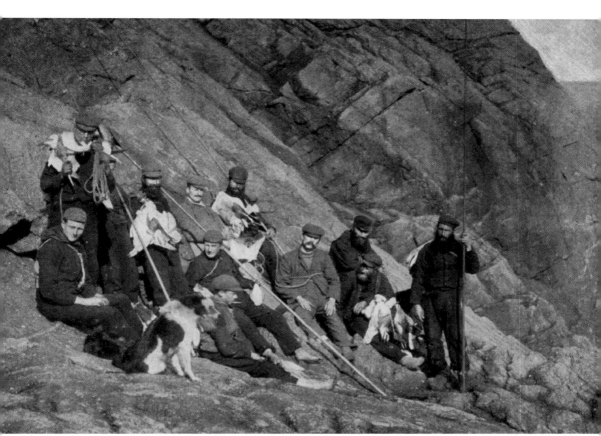

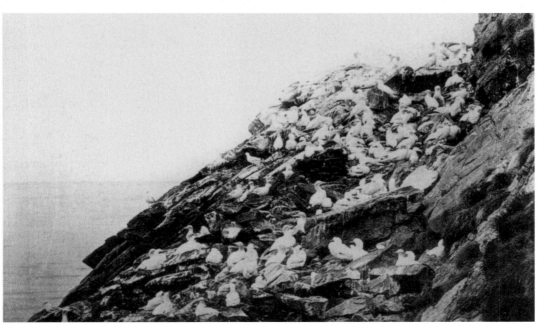

VIEWS OF ST. KILDA

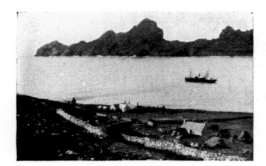

St. Kilda Bay.

Natives, St. Kilda

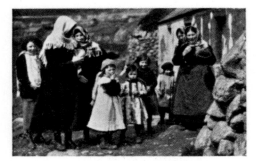

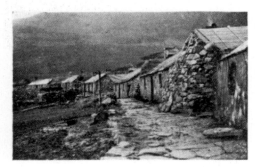

Main Street, St. Kilda

Town and Bay, St. Kilda

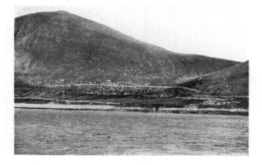

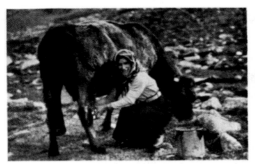

Milking, St. Kilda

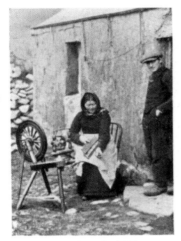

Weaving, St. Kilda

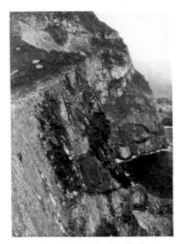

Bird Fowling, St. Kilda

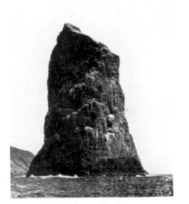

Stack Lee, St. Kilda

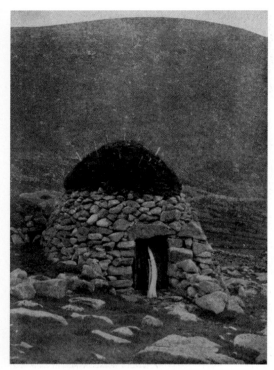

Left: *Without the thousands of cleits located on Hirta and the other islands of St Kilda, life would have been impossible. These stone buildings stored all of the needs of the St Kildans, kept everything dry over the winter and gave protection for their ropes, wool, food, snares and other items necessary to sustain life on the island.*

Below: *Although the islanders did not each much fish, a good catch was possible if one was willing to try. This was the result of only a few hours in 1898. Just think about the ones that really did get away!*

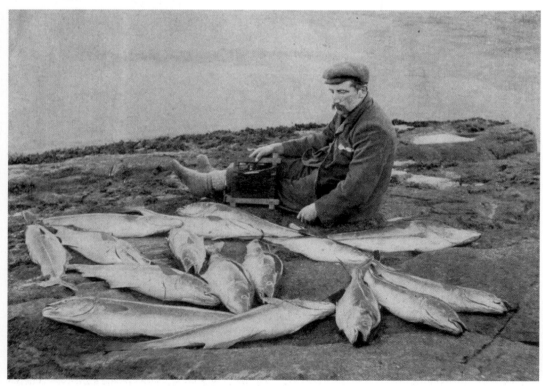

Right: *Ferguson fowling on Boreray.*

Below: *the native women spun the wool of the Soay sheep and used the thread for the manufacture of stockings, gloves and tweed. Many a dark winter's night was spent weaving in the cottages. On the left, a married woman is carding the wool prior to it being spun to make thread by the unmarried woman on the right. Rather than a wedding ring, the women of St Kilda wore a white headband to denote their married staus.*

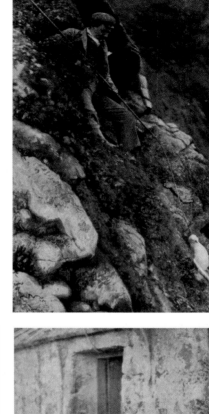

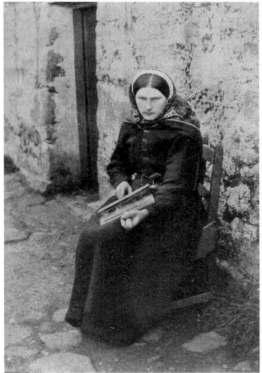

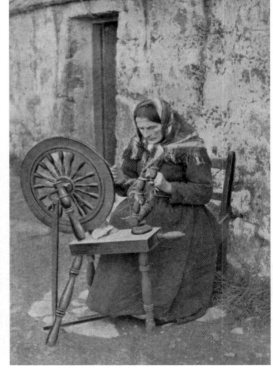

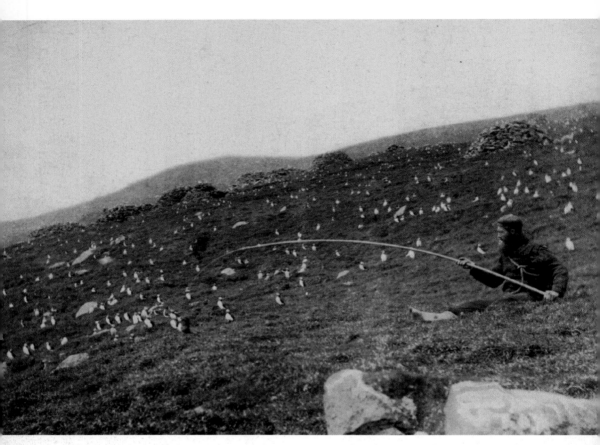

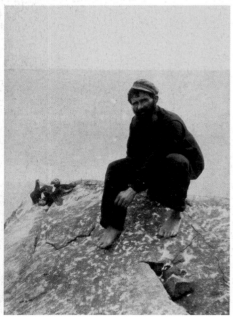

Above: *Finlay McQueen catching puffins. The St Kildans managed to consume thousands of puffins per annum and they formed a staple part of the diet. The puffin was considered a snack.*

Left: *Finlay Gillies catching puffins.*

Right: *A St Kildan Soay lamb.
The sheep are one of Britain's few
wild breeds and resemble a cross
between a goat and a sheep. They
are reputed to be descended from
animals left by the Vikings. The
Soay sheep were not sheared and,
when shears were introduced to the
island by one of the Ministers, the
natives refused to use them. The
sheep were caught and their wool
plucked by hand. The islanders'
dogs were excellent sheepdogs
although many sheep were lost each
year over the cliffs on the islands.
Some were even blown away in
winter during severe gales.*

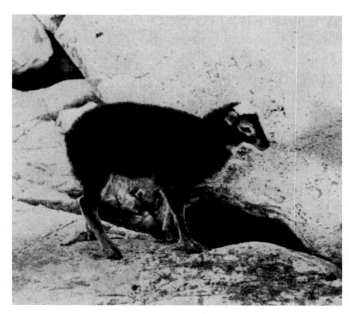

*The wool from the sheep was woven into cloth or used to make small goods. Here are some
St Kildans in the early 1930s at an exhibition, with samples of their wares and the ubiquitious
postcards for sale.*

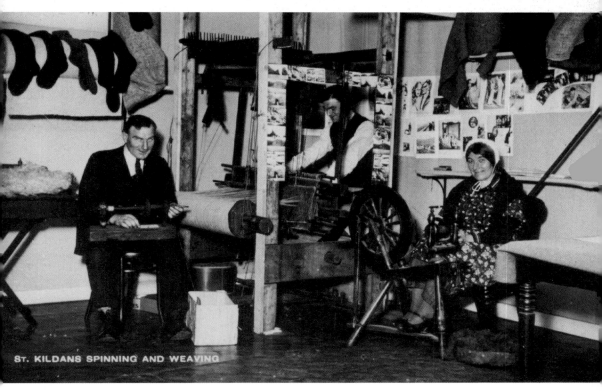

ST. KILDANS SPINNING AND WEAVING

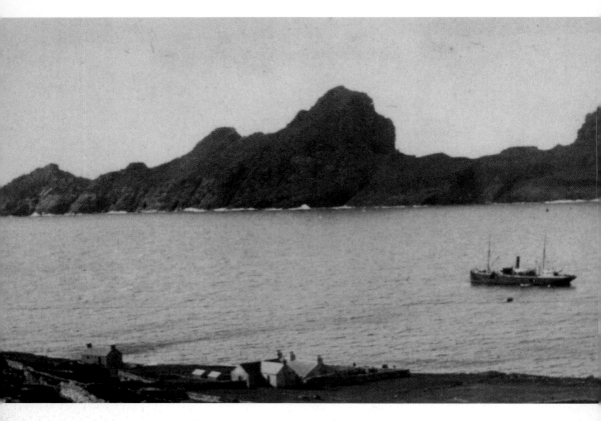

Although the best part of a complete day was spent on St Kilda, all too soon it was time to leave this primitive isle with one's souvenirs of postcards, birds eggs, woollen goods and photographs of the island at the end of the world. The factor would have bartered for the islander's produce and that which he acquired had to be loaded on to the Hebrides for the journey to the mainland. Here the ship lies in the bay awaiting its passengers and being readied for the journey back to Benbecula, the next port of call on this magical journey through the Scottish islands.

Leaving St Kilda

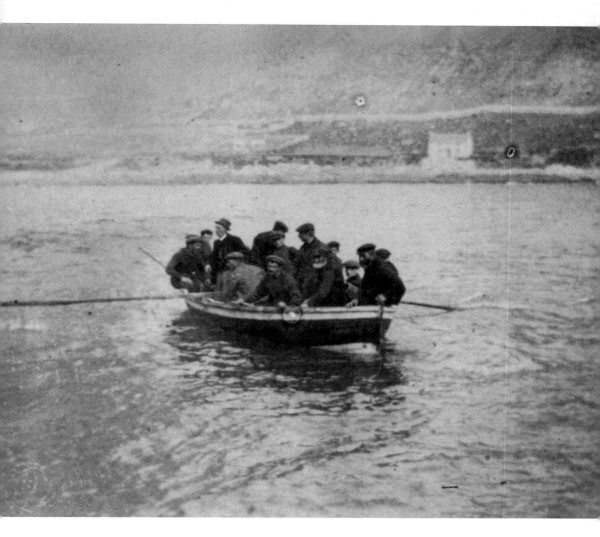

Taken from the Hebrides, some of the island men make their way to the ship on one of their boats to say farewell to the visiting tourists and to the crew and captain of the ship, which, apart from the crew of Dunara Castle and the factor, were the only regular visitors to St Kilda.

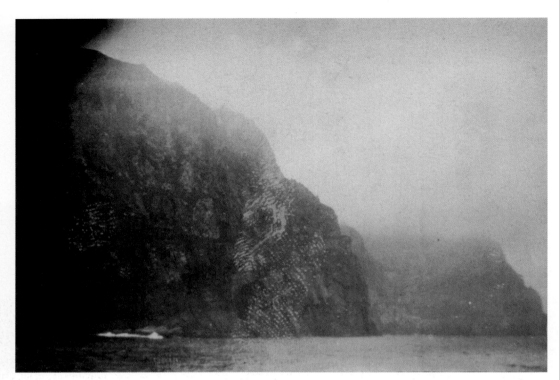

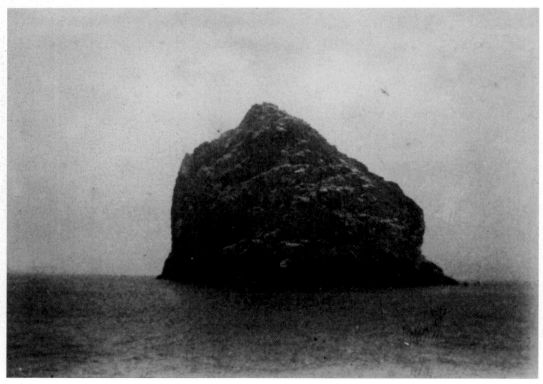

Opposite, top: *As the ship was about to leave St Kilda there was time to take photographs of the island scenery from the sea. As was quite common on St Kilda, the mountain peaks were covered in mist while below the breakers crashed against the bottom of the sea cliffs.*

Opposite, bottom, left: *The peak of Stac Lee, one of the highest stacs in the UK at 544ft, and only topped in the St Kilda archipelago by Stac Armin, at 627ft the tallest stac in Britain. The writer R.A. Smith wrote of the stacs around St Kilda in 1879 and had this to say of Stac Armin and Stac Lee: Had it been a land of demons, it could not have appeared more terrible, and had we not heard of it before, we should have said that, if inhabited, it must be by monsters.*

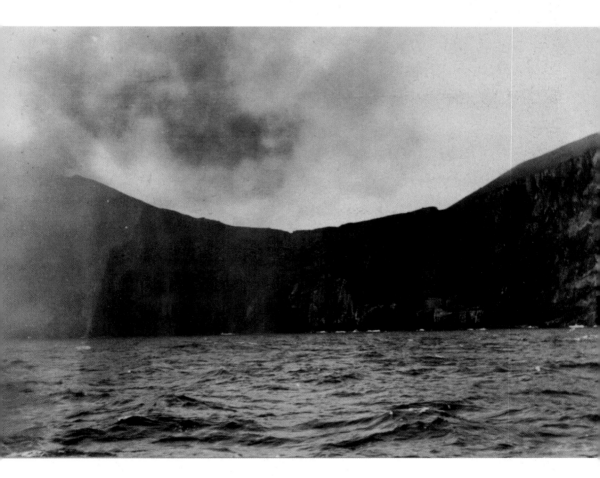

The peaks of Dun from Village Bay.

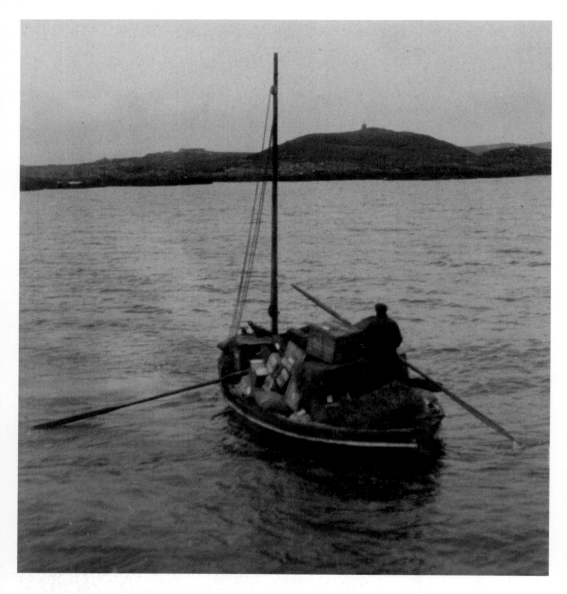

From St Kilda, the Hebrides sailed for Benbecula where calls were made at Scotvin and Carnan. At neither village was there a pier and all goods were transported from ship to shore by ferry boat. Nothing glamorous here, just a couple of small boats rowed out to the ship and loaded from the side with as much as they could carry without capsizing and then rowed or sailed back to shore. Sacks and cases were lowered by rope to the awaiting ferries and enclosed within were all of the supplies that a remote community required but could not grow, hunt or catch as well as luxuries from the mainland.

'The anchor is dropped at Scotvin and Carnin in Benbecula.'

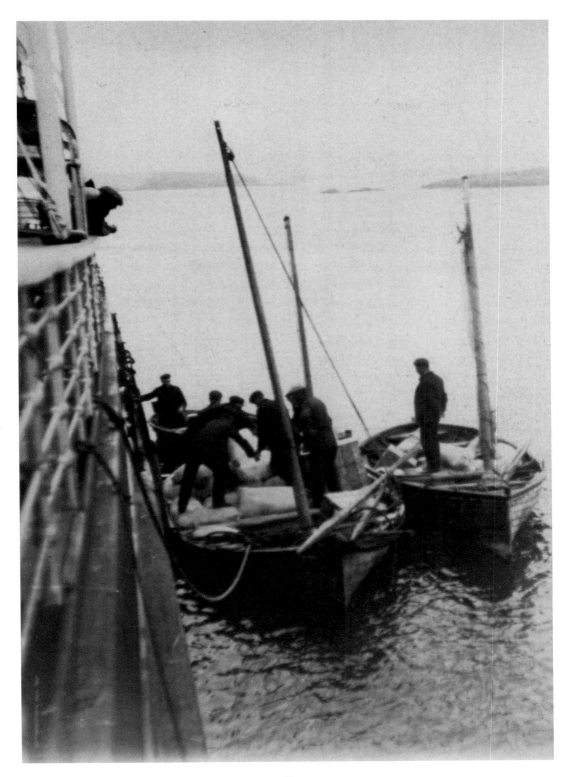

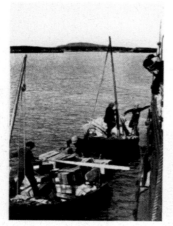

LOADING FERRYBOATS, BENBECULA

A CROFTER'S FAMILY, SOUTH UIST.

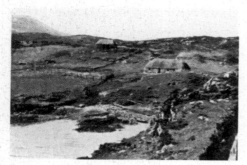

CROFTS, SOUTH UIST.

'Lochboisdale is the chief port in South Uist, and has a pier.'

Opposite, above: *Lochboisdale's main street, next to the harbour, with the Lochboisdale Stores centre.*

'Lochboisdale is reached in the afternoon.'

Opposite, below: *A typical Western Isles home. This black house was typical of housing across the Hebrides. Designed to keep both man and beast in some comfort over the winter months, its roof was of turf and the walls of stone up to five feet thick. There were few windows and the fire at the right hand end would have been open in the middle of the floor. During the winter the cattle were accomodated here too.*

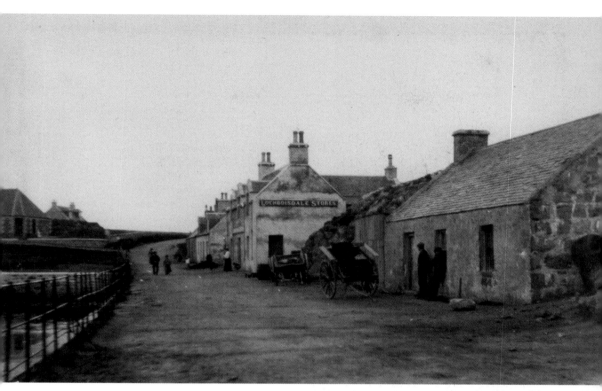

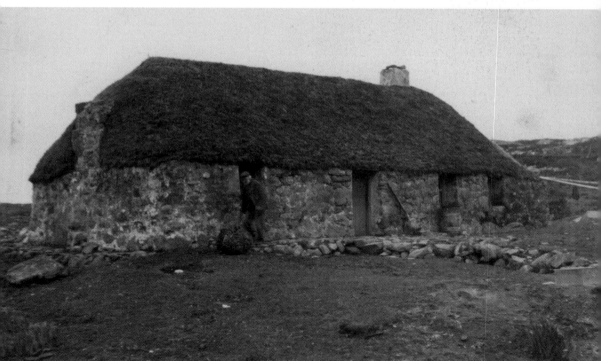

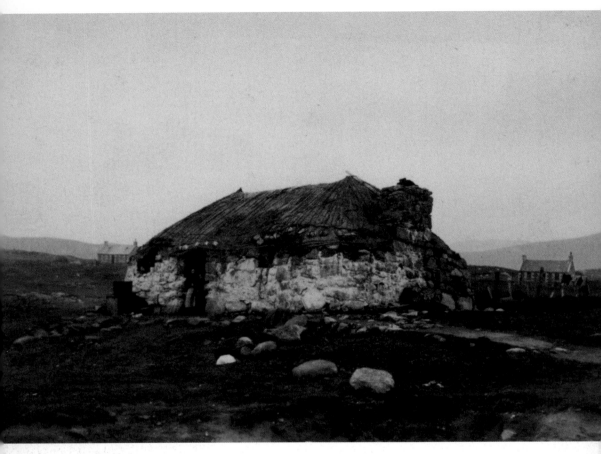

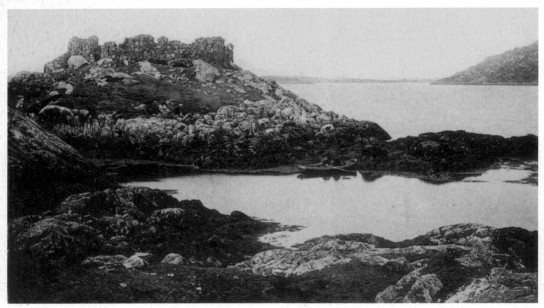

Oppostie, above: *Another black house at Lochboisdale.*

Opposite, below: *Calvay Castle is a thirteenth-century ruin visible from the steamer as it enters the sea loch.*

Below: *This postcard was part of a set of over 250 different cards issued from Uist of views of the islands. This Gaelic set, called Cairt Phostail (Post Card in Gaelic) was issued from about 1902. Here, three walkers enjoy a tot of aqua vitae.*

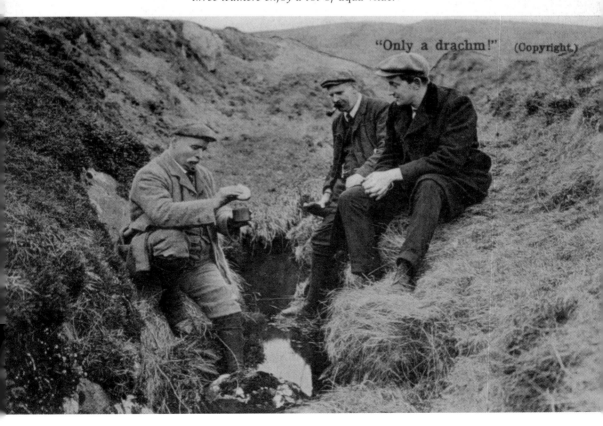

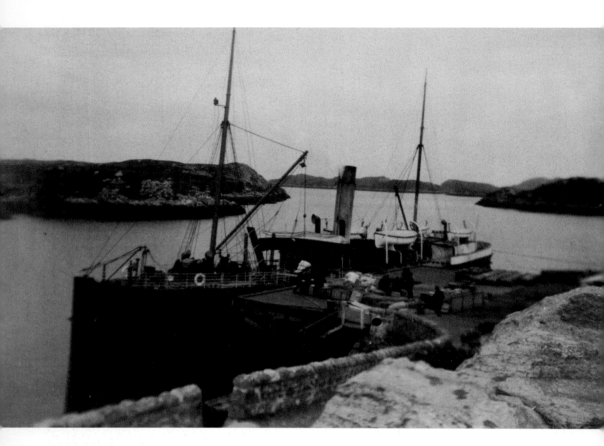

Hebrides *at the pier, Lochskipport. From here, she sailed past the Sound of Eriskay, where Bonnie Prince Charlie landed in 1745. On Eriskay a plant named the Prince's Plant is grown. The ship arrived at Barra at nightfall and remained there the night.*

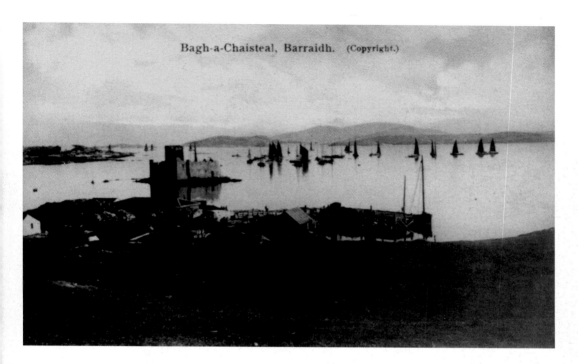

Bagh-a-Chaisteal, Barraidh. (Copyright.)

The scenery in Barra is bold and wild. Its west coast has high cliffs and extents of white sand, against which the Atlantic waves make dreadful turmoil. After entering Castlebay, the picturesque ruins of Keismul Castle attract attention.

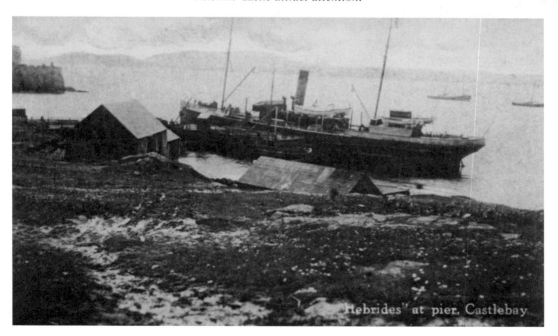

"Hebrides" at pier, Castlebay

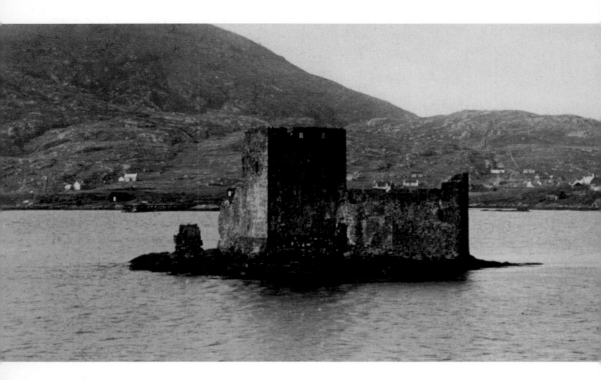

Keismul Castle was the ancestral home of the MacNeils, Lairds of Barra, some of whom were pirates. At the time of the visit of our tourists in 1911 or 1912 Castlebay was a thriving village and in the months of May and June it was a hotbed of the fishing industry as boats from far and wide congregated here as the herring migrated past the island. The harbour could have as many as 7-800 fishing boats in residence and the shores were alive with fisherwomen gutting and packing herring for export.

———•◆•———

'Leaving Barra, the steamer makes across the Minch for Tiree, where a view may be had of Staffa and Iona, and the Treshnish Isles. After calling at Coll and Tobermory, acquaintance is renewed with the beauties of the Sound of Mull.'

———•◆•———

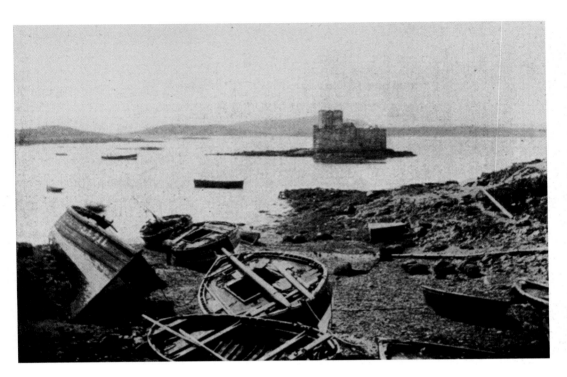

Barra c.1910. Castlebay is far removed from those hectic 'gold rush' times when the British fishing fleet was huge and the numbers of fish were high. The scenery here has always been fantastic and the island is most definitely one of contrasts, from the high cliffs of its western coast to its white, sandy beaches. Just south of Barra are five substantial islands called the Bishop's Isles, on the southernmost of which is Barra Head lighthouse, perched 600ft above the sea.

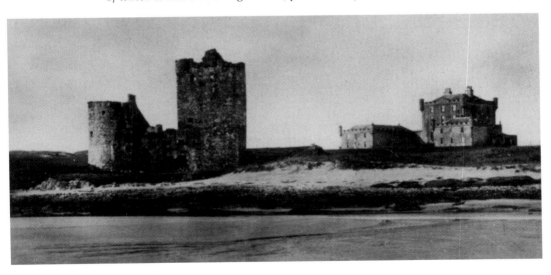

On Coll the tourists would have had the opportunity to see the castles, both located together, with old and new contrasting greatly in design and function.

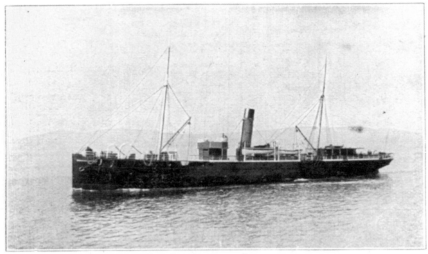
Brochure for the Dunara Castle, *from 1910.*

Chapter Four

Life on Board

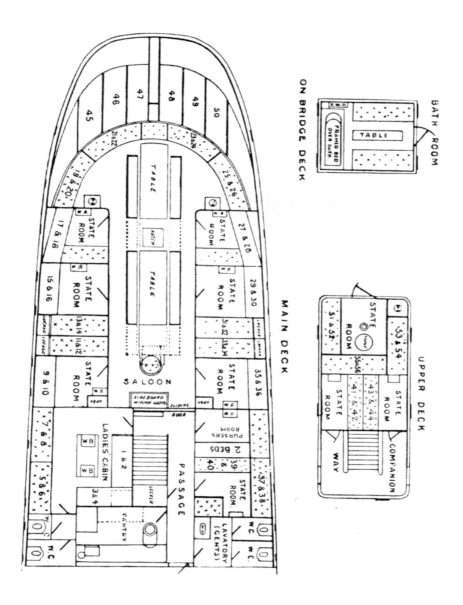

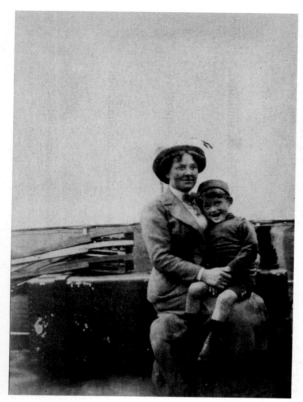

The Hebrides *was primarily a working vessel. Her whole* raison d'être *was to supply the outlying isles with produce that could not be acquired locally. She also served as the only means of regular communication for many communities along her route and she was the main method of getting goods and produce from the Western Isles she served to market, whether that be Oban or Glasgow. Tourists were a bonus, not that they weren't well provided for. Cabins were comfortable and the food good. Although many calls were short, leaving little time for sightseeing, the ship spent at least seven nights away and the passengers could visit local hostelries and sights.*

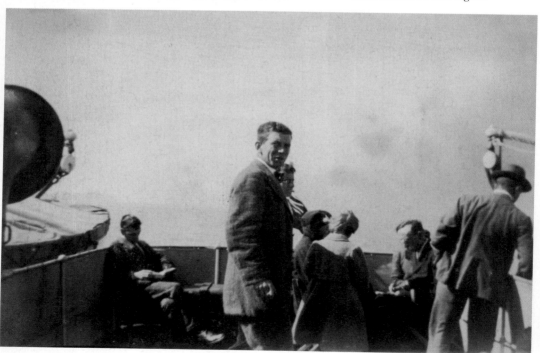

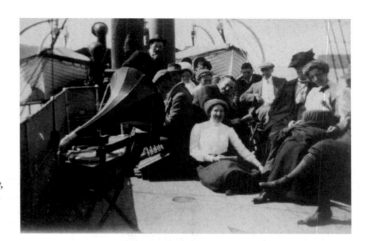

On board, when sailing, there was little in the way of organised entertainment. Passengers could read, view the magnificent scenery, or lark about on deck. Here, they are listening to the gramophone that they took to St Kilda.

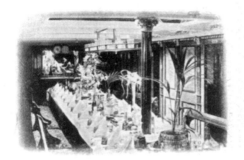

Dining Saloon, S.S. " HEBRIDES."

All Passengers and their Luggage carried subject to conditions in Sailing Bills, copies of which may be had on application.

N.B.—There are Piers with Telegraph Stations convenient at PORTASKAIG, OBAN, TOBERMORY, CARBOST, DUNVEGAN, LOCHMADDY, LOCHBOISDALE, & CASTLEBAY, Barra ; and Wireless Messages can be forwarded through any Post Office addressed:—"Passenger, Steamer 'Hebrides,' Radio, Malin Head."

Meals were taken in the dining saloon, which was surrounded by the cabins at the stern of the ship. Locating the cabins and the passengers here kept them away from the part of the ship where all of the work was undertaken.

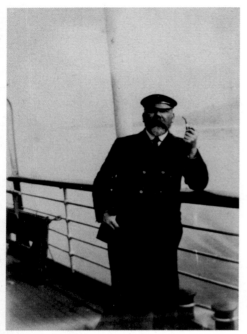

Left: *The Captain of the* Hebrides, *looking just as o[ne]
would expect, with his grey beard and pipe.*

Below: *A deckhand working one of the derricks on
board, loading and unloading at a West Highland pi[er]
probably Lochboisdale or Carbost. These men wer[e]
the unsung heroes of St Kilda and the main reason
that evacuation was not undertaken until as late as
1930. They kept St Kilda alive, encouraging trade an[d]
ensuring that the islanders were supplied with food
and all the necessities of island life. They brought
tourists with money to spend and encouraged trade[.]
Without them, this book and the lives of those on S[t]
Kilda would not have been possible.*

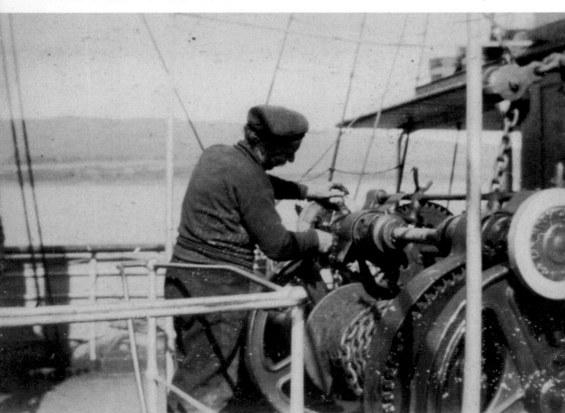